apula may be too large?

testicles
internal

tail cylindrical but
flattened towards tip
1·5 m max

imb at
vertically

a spreading on contact.

THE SCULPTURE OF
DAVID WYNNE
1974-1992

DAVID

THE SCULPTURE OF

WYNNE

1974 - 1992

Edited by Jonathan Stone

Lund Humphries

London

First published in 1993 by
Lund Humphries Publishers Ltd
Park House, 1 Russell Gardens
London NW11 9NN

British Library Cataloguing-in-Publication Data
A catalogue record for this book is available from
the British Library

ISBN 0 85331 638 4

Designed by Barrington
Filmset in Bembo
Paper: Pavilux matt white and cream
Made and printed in Great Britain
by Lamport Gilbert Limited, Reading

CONTENTS

KENSINGTON PALACE

David Wynne is a remarkable man with a remarkable, God-given talent for extraordinarily sensitive sculpture. He is someone who puts his heart and soul into whatever he is doing and, as a consequence, we are able to obtain infinite pleasure from the result of his labours. How wonderful it is to be able to give such unalloyed pleasure as a by-product of your artistic endeavour.

We are all the richer for David Wynne's talent and long may he continue to enrich us.

This book is dedicated

to my beloved wife Gilli,

without whose help and

encouragement my sculpture

would be much worse

Gilli Walking 1991, plaster state

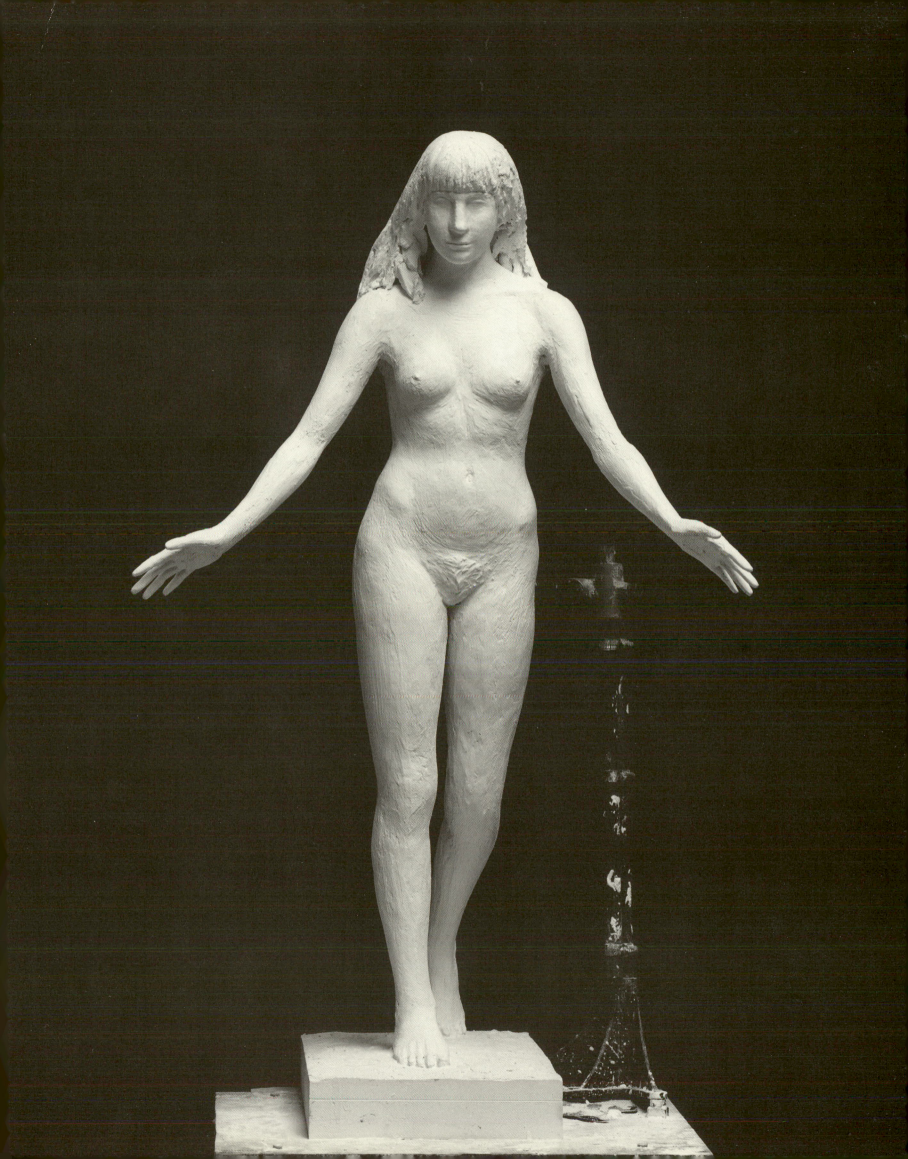

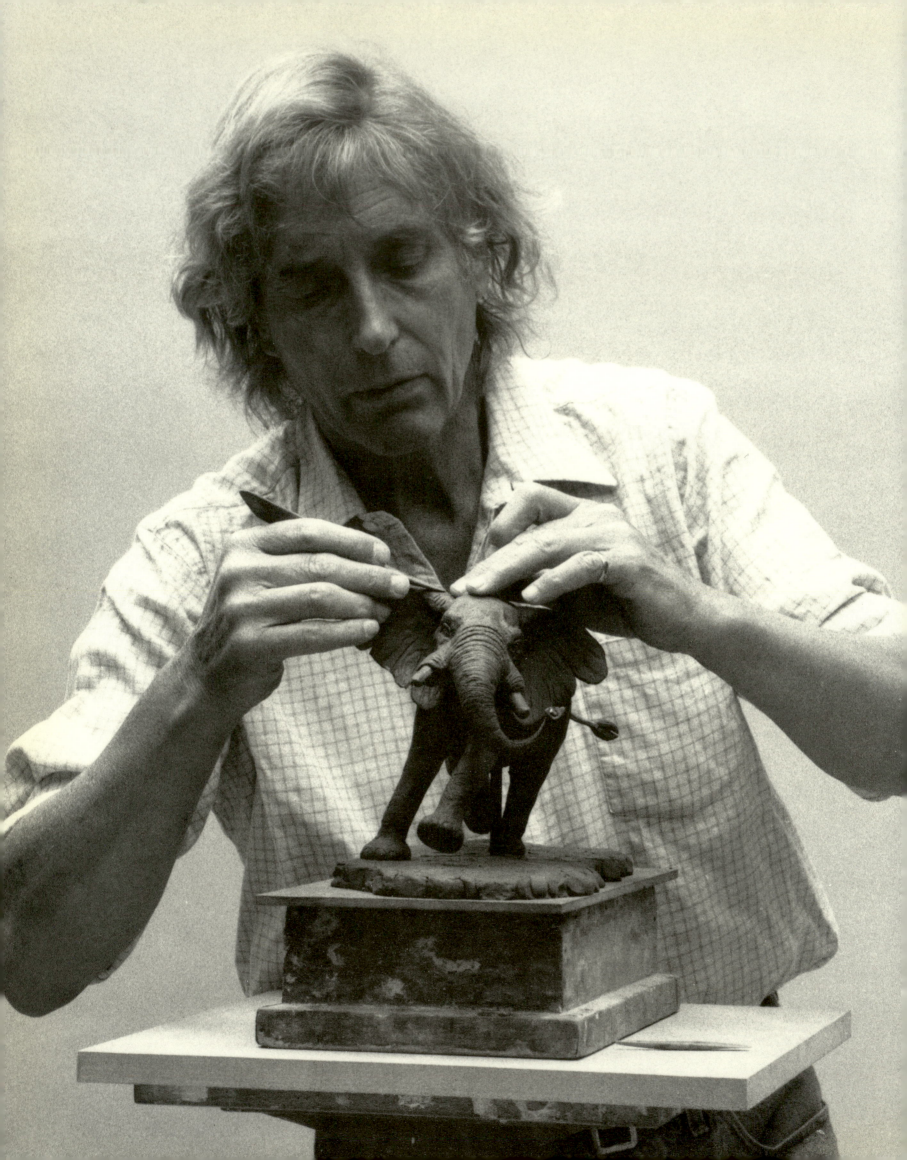

INTRODUCTION

This book covers David Wynne's work over the last eighteen years, with sections on most of the larger sculptures completed during this period. There is also a collection of essays by some of the people who have been closely involved with him during this time, as patrons, as friends or as sitters.

David Wynne is now 66 years old. So often during the middle years of an artist's life the joy and naivety of youth fade. It is a time when their work can become repetitive and lacking in vibrancy, when success can lead to a loss of that goad which forces the risking of all and the willingness to suffer the agonies of creation. Not so with David. Consider the awesome task of carving a Christ for the West Front of Wells Cathedral, the vitality of the Sheffield Horseman, the tension of the Two Swimmers, and the serenity and power of the five large Goddess carvings.

This artist believes as did the ancient Greeks that real art, together with real philosophy, real science and real religion, are the four pillars of civilisation, raising us from the slough of materialism. He tries to hold his subject up to the light of God. To model for David is to feel that one has been seen truly and that

one's body has been celebrated as a part of the planet, a vessel for bringing harmony out of chaos and a new object of beauty into the world.

David has never sought the assurance of keeping something in reserve, nor has he conformed to the platitudes of social convention. In this he was encouraged by his wife Gilli, whose great maturity and compassion, whose understanding and eye for art were David's guiding light until her death in 1990.

Less comfortable for those around him is his lack of consistency as he follows where his instincts lead. David's ability to recognise and appreciate the source of inspiration, whatever the field, is reflected in the wide range of his loves. He may one day be carving a huge marble block and the next day have flown unheralded to Africa to make models of some strange animal in the bush.

When first working as his assistant, on *The Messenger*, I found it difficult to accept the paradox that we were making both a horse and a symbol of the essence of horse to convey a message. That message is best put in David's own words:

'The object of art is praise. It is to communicate emotion, to remind us of another order, where all is harmony.

'It is as though a traveller returning from a voyage to another world was asked what it was like and what he had seen. He cannot say. But he smiles and says, "I brought this back." All who see it say, "Surely I have seen that before. It reminds me of what I felt when I was a child."

'Artists of every generation help us to remember why we came and where we are. For the real world is not about politics, or newspapers, or money, or prisons, or evil. Evil does not exist, except as a mirage, the shadow of good.

14

'If one reads the great magic books – The Koran, The Upanishads, The Bible – a word which so often appears is "praise". To praise creation is the object of art and the object of life for man. The animals and the plants do it naturally, we have to be constantly reminded. To listen to music, to hear poetry, to see beautiful buildings, or paintings, or sculpture reminds us why we are here, for these are in praise of the creation.

'When I decide to make a sculpture of a beautiful girl or a rare animal I am striving to worship that creature, and thus to worship nature. I try to love it as the creator loves it and to see it through his eyes. When I make a portrait head I try to tell the truth lovingly: never to belittle, nor ridicule, nor caricature. Find what is most perfect, most beautiful, and most essential, this is the core of what I am trying to do.'

The supreme confidence David Wynne has in himself and his belief in the necessity and uplifting nature of art stimulates and enriches the lives of those whose paths he crosses. The animal experts see their animals more clearly and love them more dearly, the men of the foundries, in the quarries and on site, are inspired to produce their best, and his patrons are given a breath of fresh air.

The past eighteen years of David's life have had some wild phases and periods of darkness, but always he returns to his serene belief in the world. In his own words, *'Paradise is here, now'*.

Robin Caiger-Smith
Newnham 1992

LARGER SCULPTURES

1974

Boy with a Dolphin

BRONZE, 156″

First Federal Savings Bank, Worcester, Massachusetts

Wates Ltd, for Pier House, Cheyne Walk, London

Graysons Bank, Sherman, Texas

The Mayo Clinic, Rochester, Minnesota

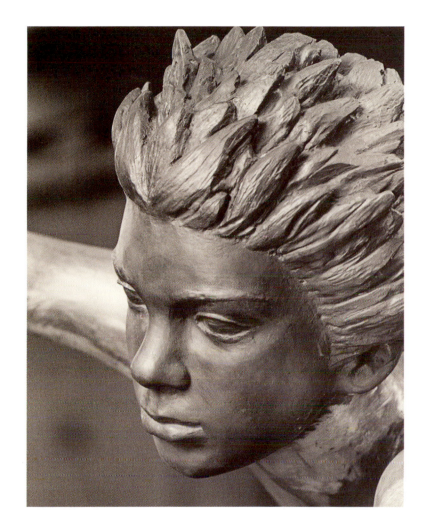

Detail of *Boy with a Dolphin*

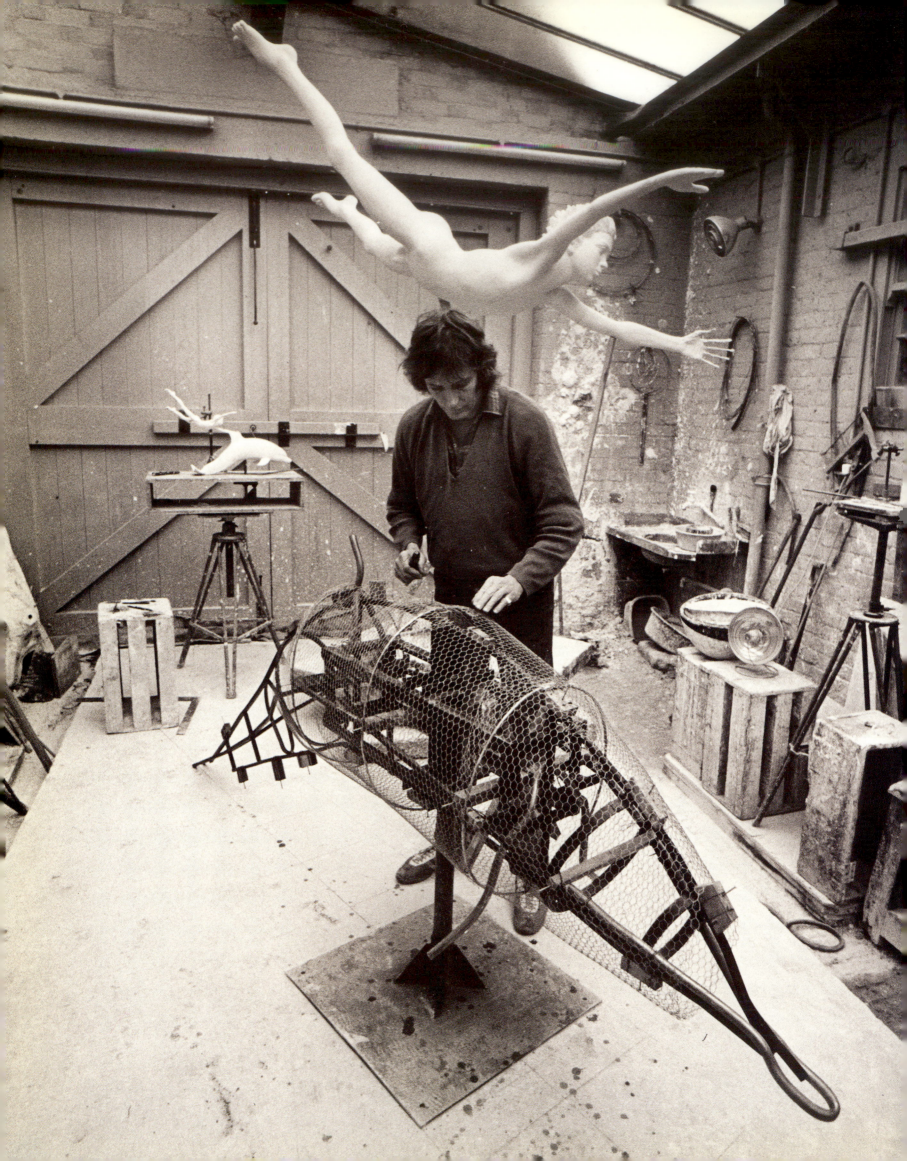

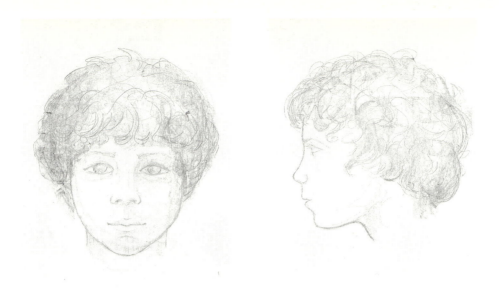

The drawings are of the sculptor's son Roland, who posed for the boy.

As this sculpture was to be modelled directly in plaster, the armature was a complex piece of engineering, made of steel, lead, wood, aluminium and copper.

Here Bill Amer and the sculptor are discussing the uniting of the two figures.

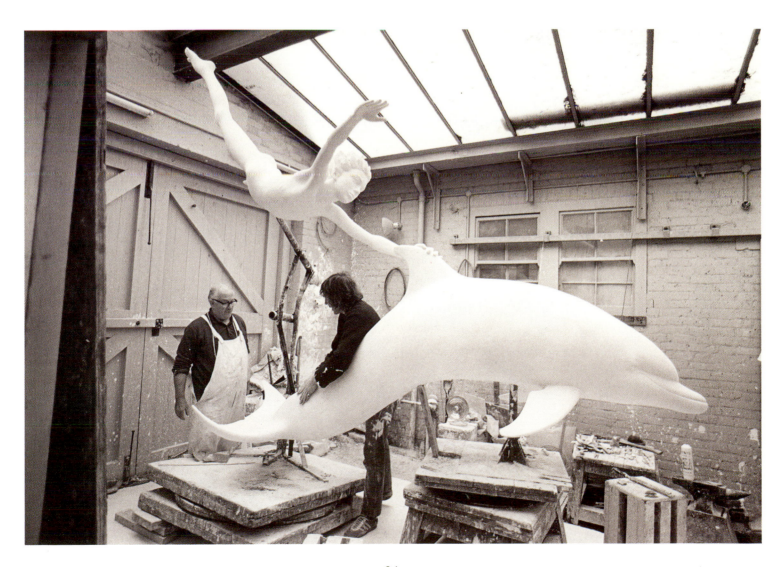

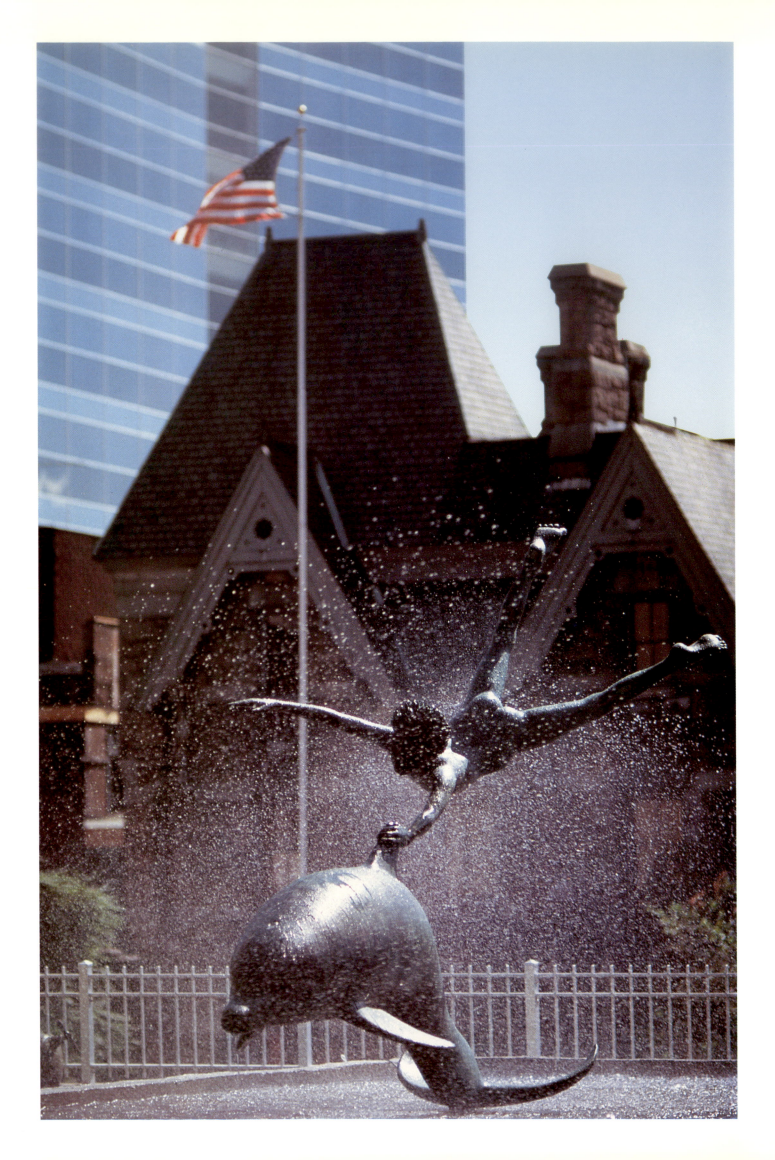

Dolphins have ever been symbols of
freedom and happiness.
The boy seems released from earthly ties
as he rides the dolphin wave.

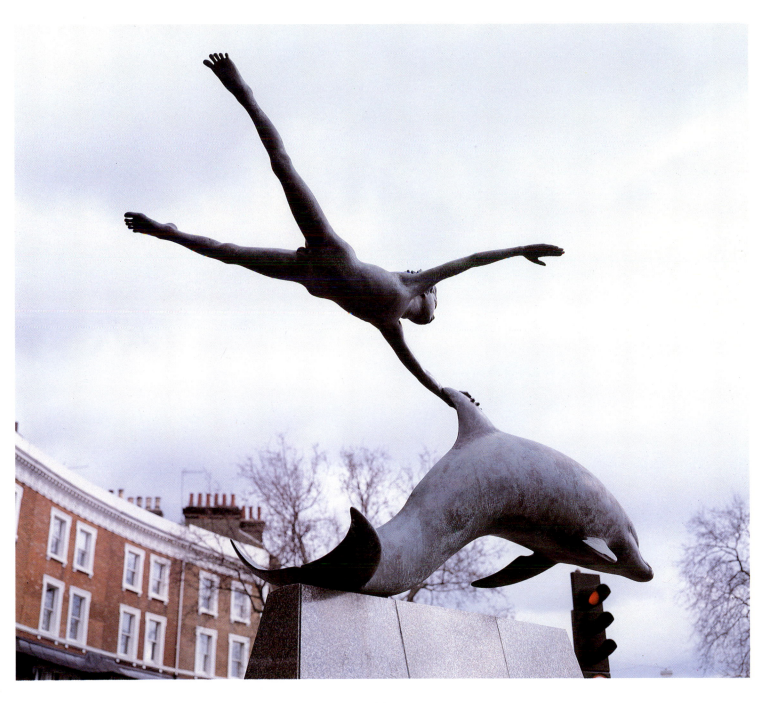

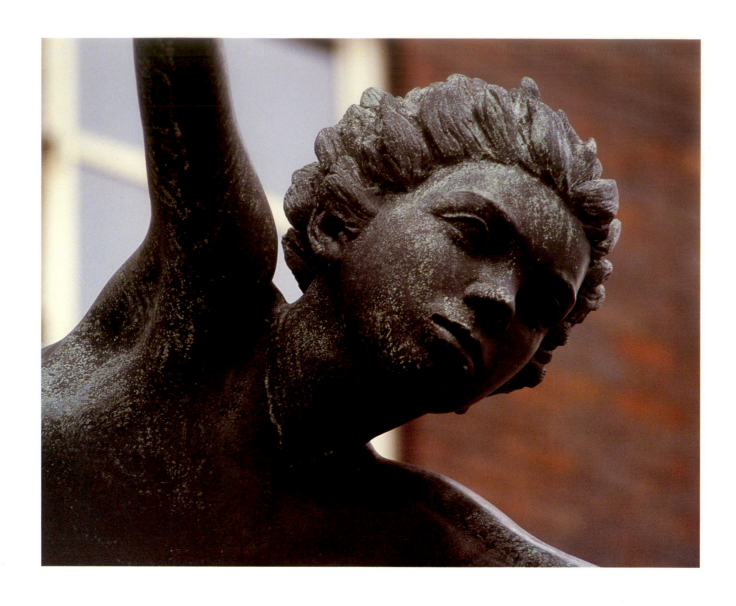

The cast in London was installed in 1975.
It is probably the best loved of all
the sculptor's large work in London.

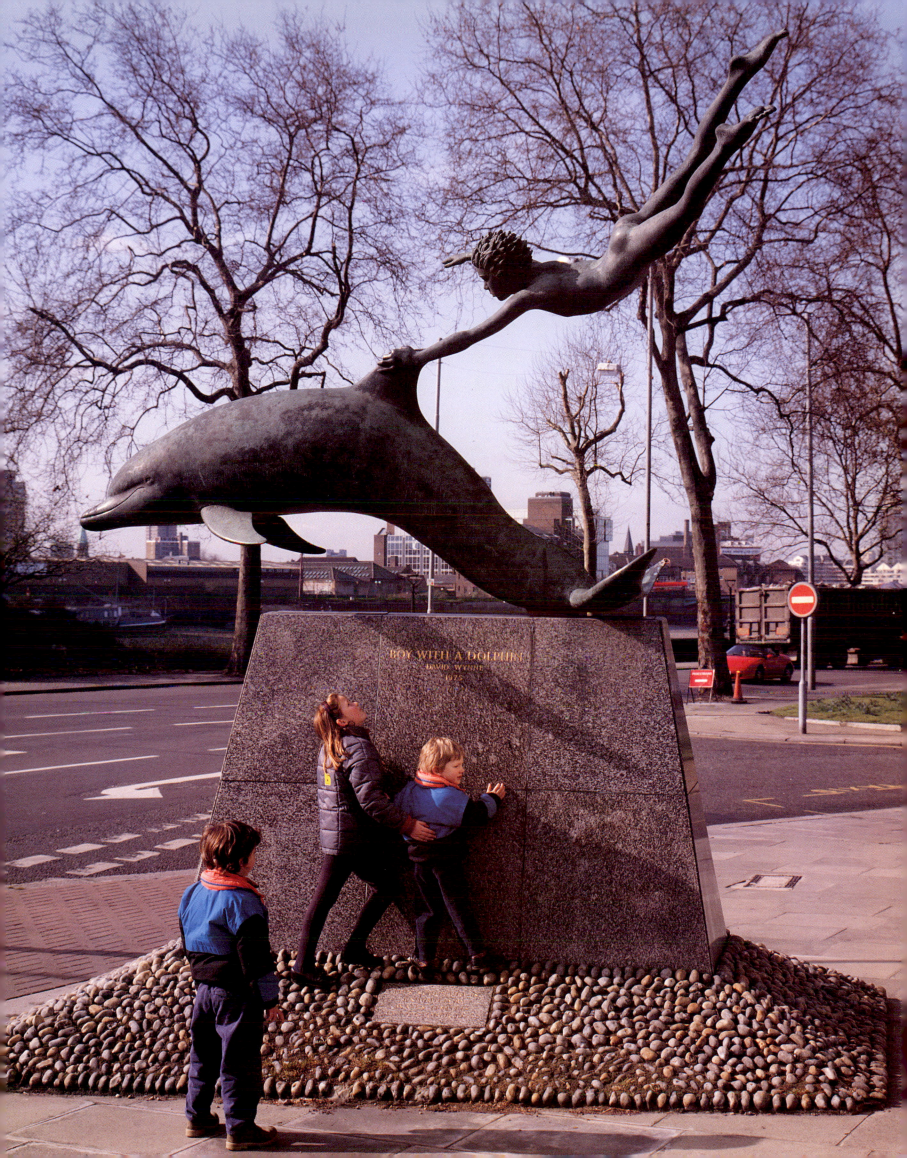

1976

Grizzly Bear

BLACK FOSSIL MARBLE, 144″

PepsiCo Sculpture Park, Purchase,
New York

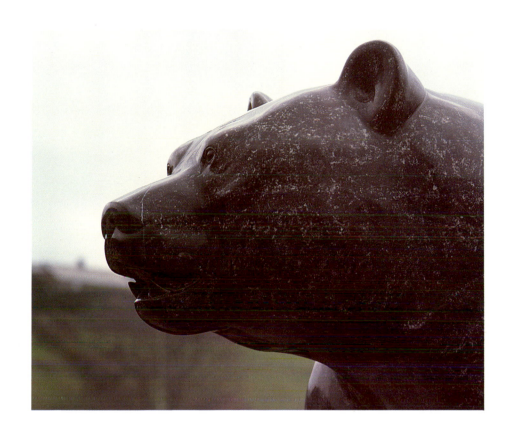

Detail of *Grizzly Bear*

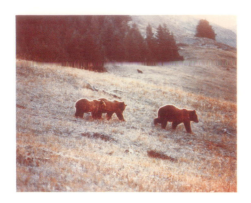

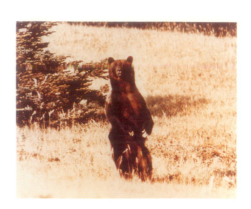

The sculptor travelled to the high Rockies
to draw and film grizzlies in the wild.
He was led by Bill Vroom, a park warden
from Banff National Park in Alberta.
He then returned to England to model the maquette.

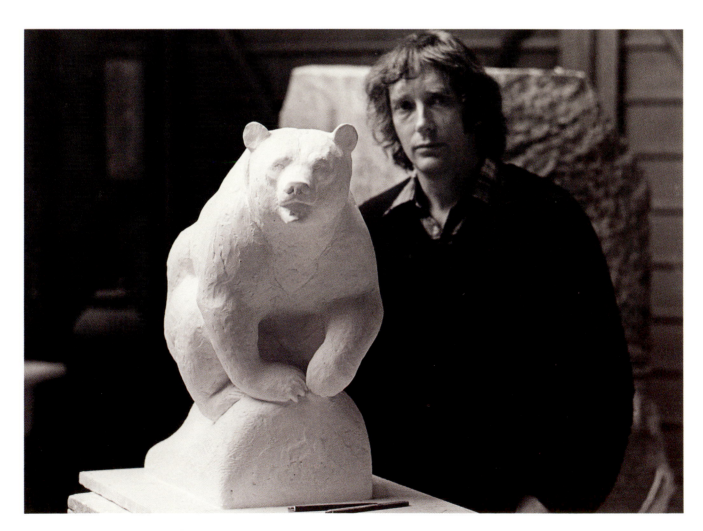

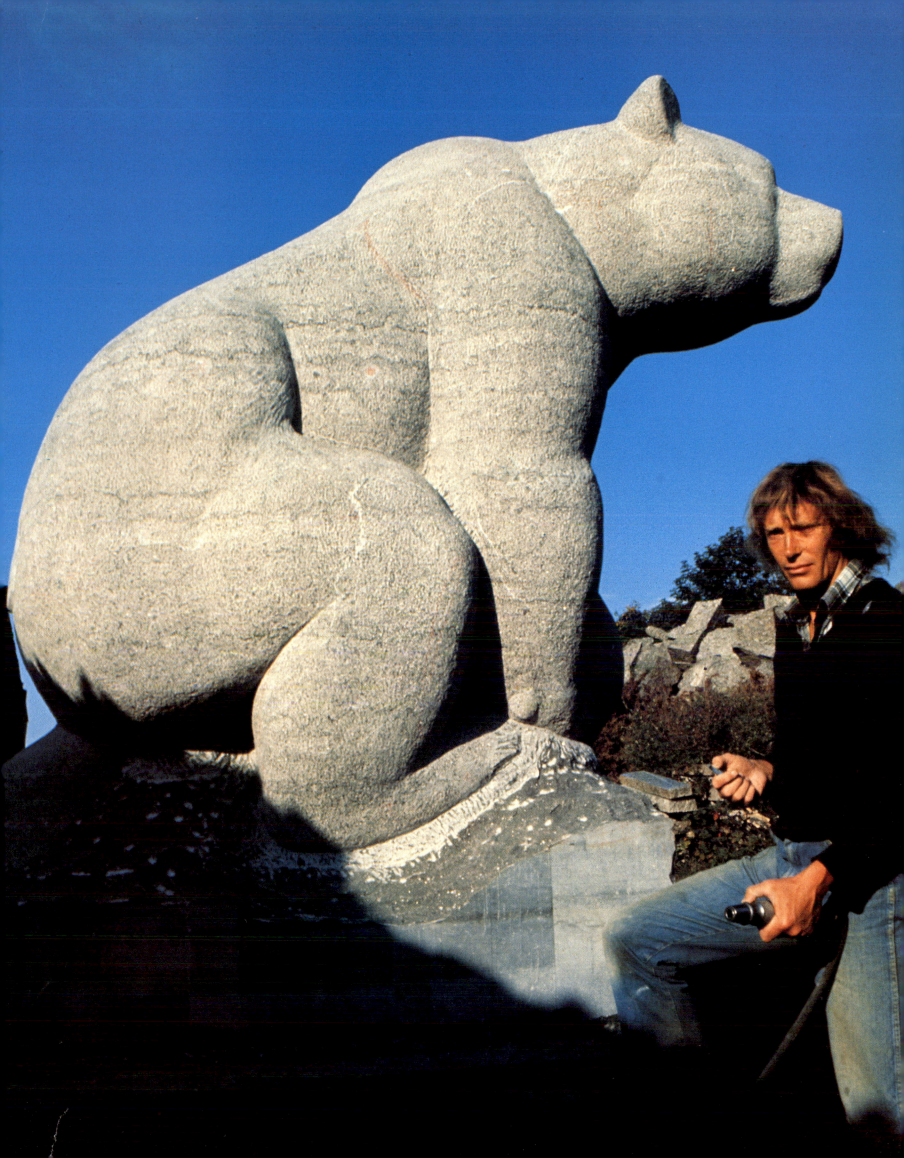

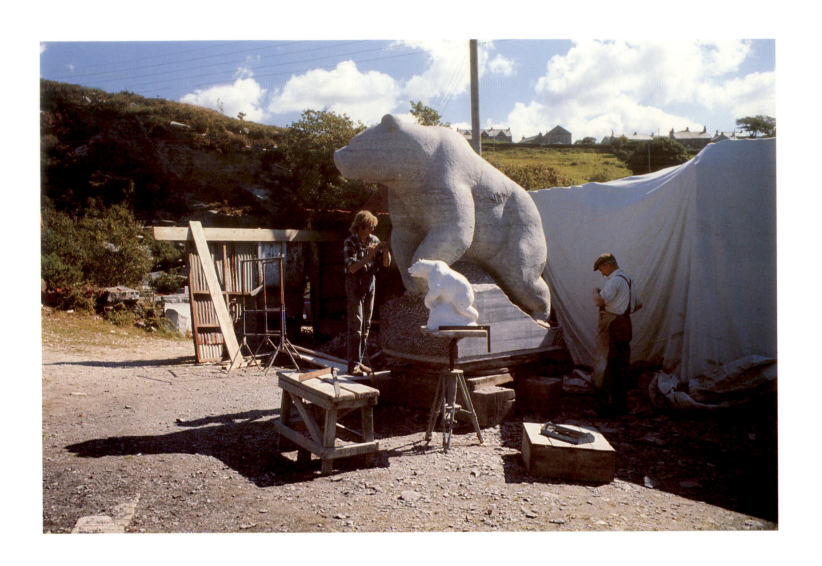

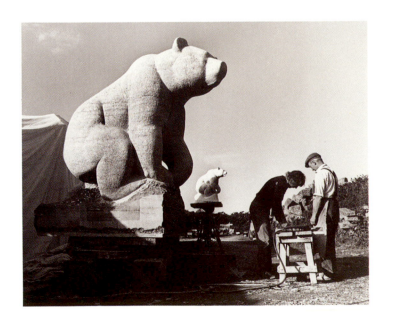

The block of marble was carved in a quarry on Bodmin Moor in Cornwall. The sculptor had the help of two granite masons, Les Williams and Peter Nottle, for nine months. Slowly the bear emerged. Here Les and the sculptor prepare for the final polishing.

When the carving reached its final destination it was lowered with infinite care to its resting place in the grounds of PepsiCo. The chairman, Donald Kendall, can be seen watching while the sculptor rides the bear.

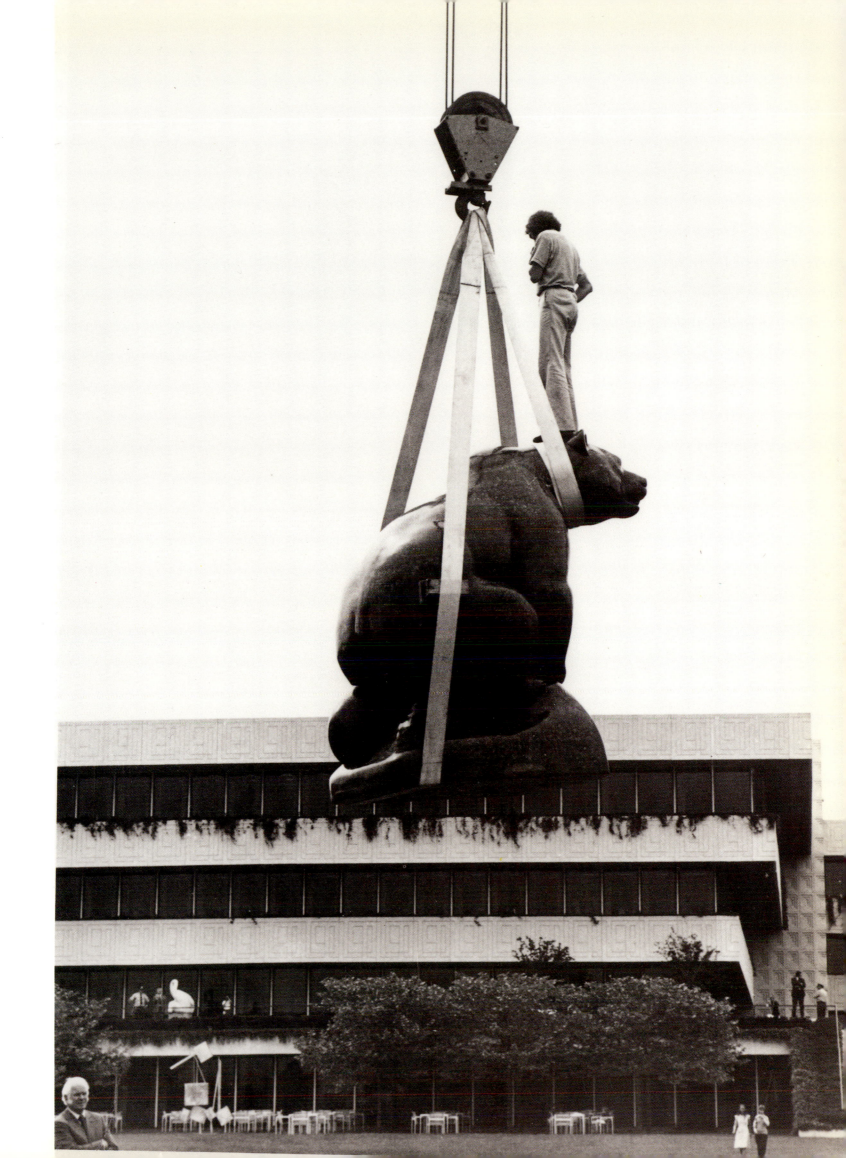

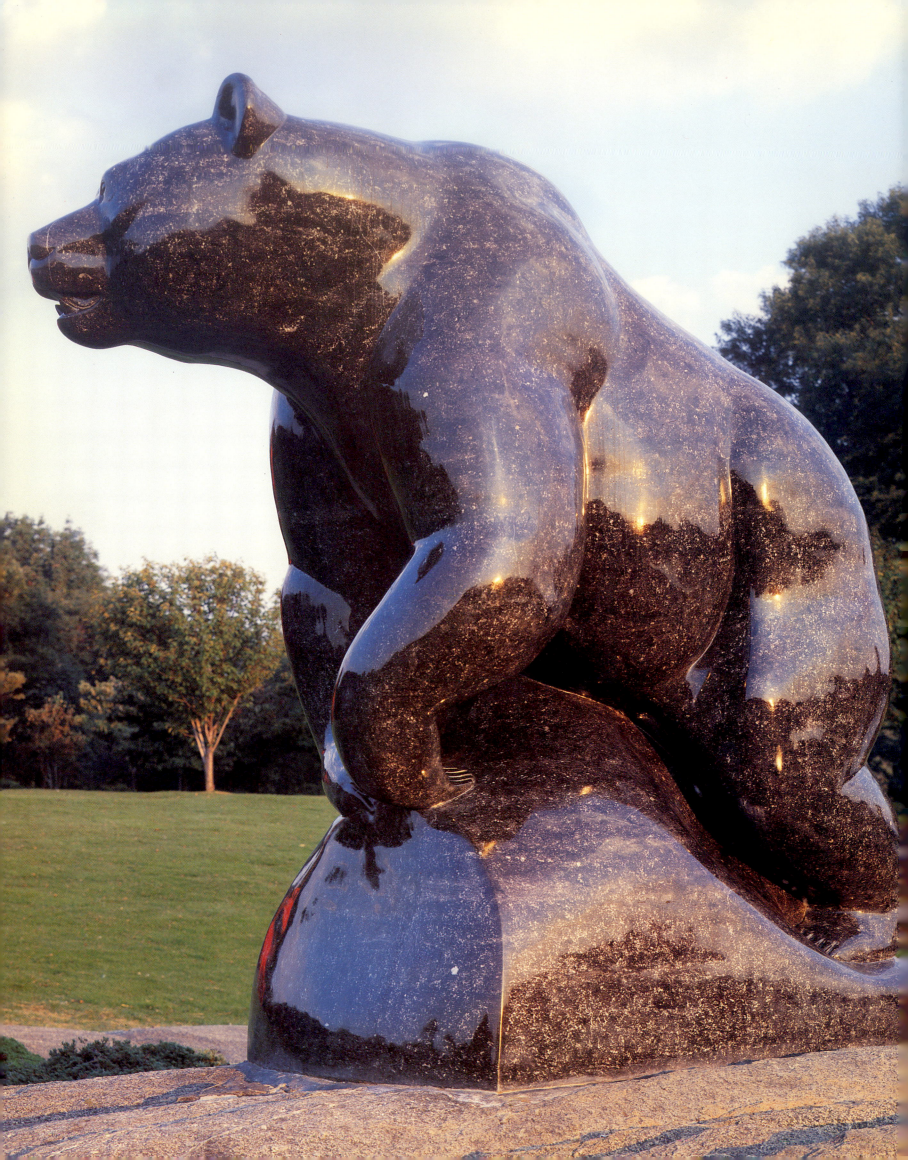

The pose chosen for the bear is a strange one.
Grizzly bears are being shot out of their last
stronghold in the high wilderness. Once they
roamed from Florida all the way to Alaska.
Now there is no place on earth where
grizzlies can live in peace. So he is standing on
the edge of a cliff, on the precipice of extinction.

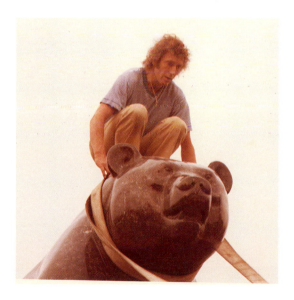

1 9 7 8

Horse and Rider

STAINLESS STEEL, 144″

Fountain Precinct, Sheffield

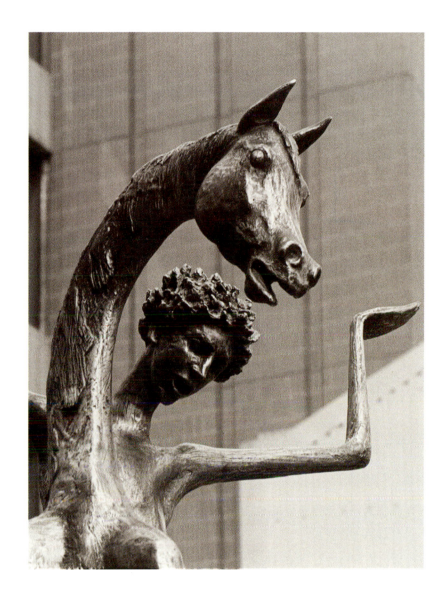

Detail of *Horse and Rider*

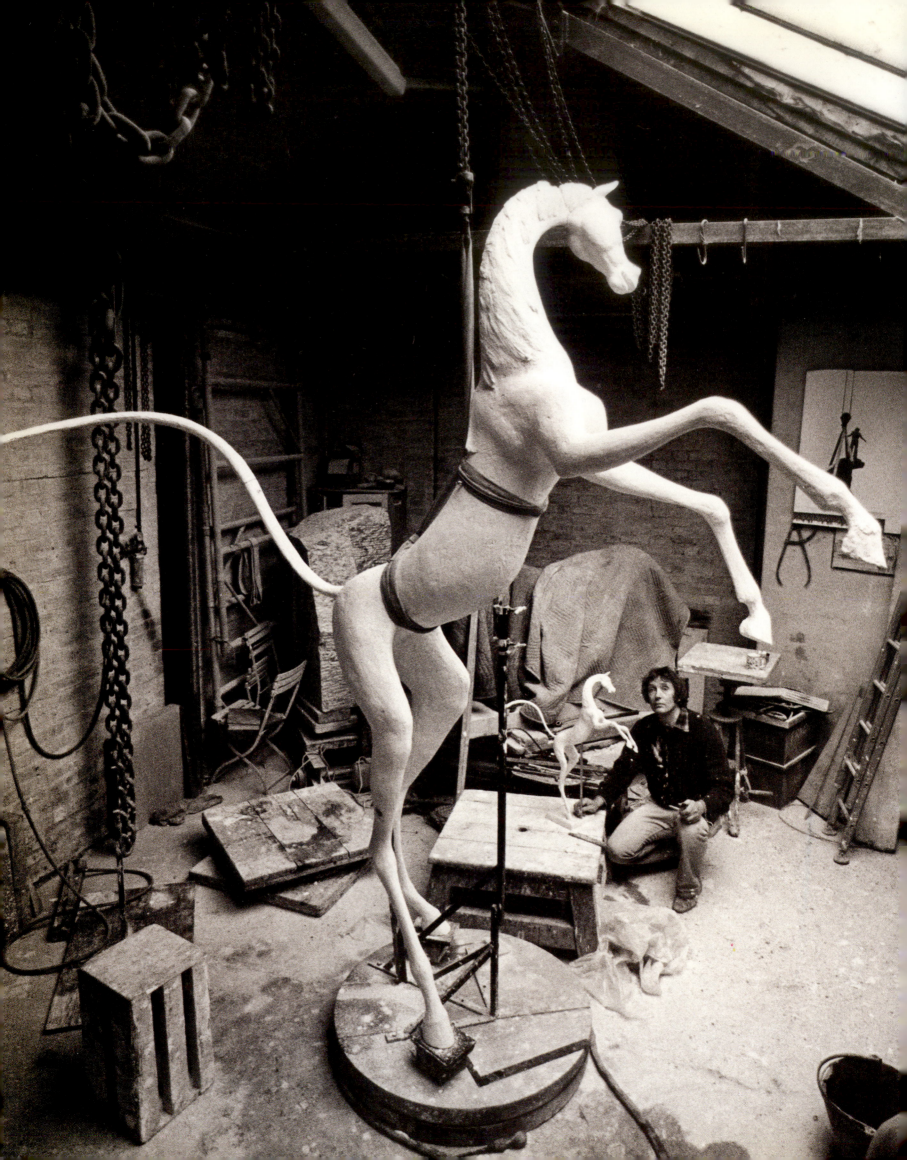

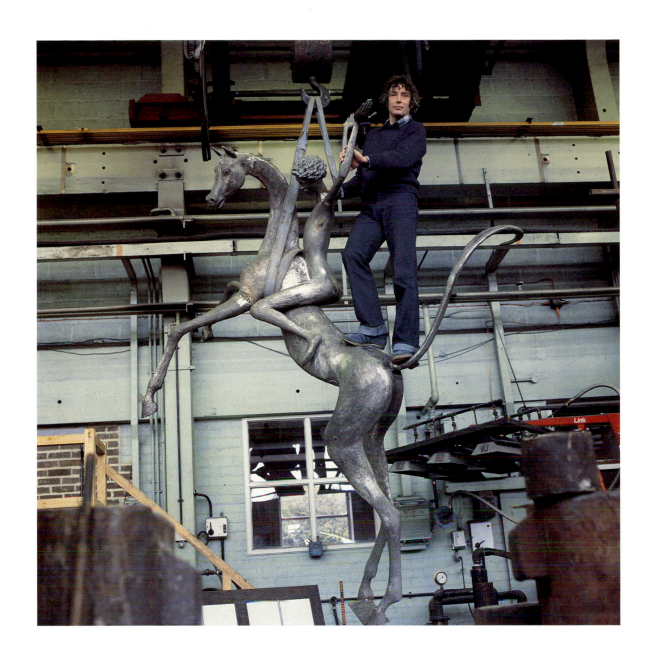

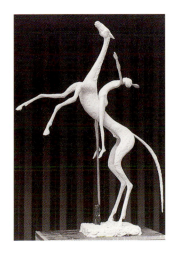

This piece was commissioned by Jonathan Stone,
the editor of this book, in memory of his father, who
was a citizen of Sheffield. The inspiration was
the White Horse of Uffington, a huge Celtic chalk
figure on the Marlborough Downs.

The design was settled after several maquettes were made.
The sculptor's son, Edward, posed for the rider.

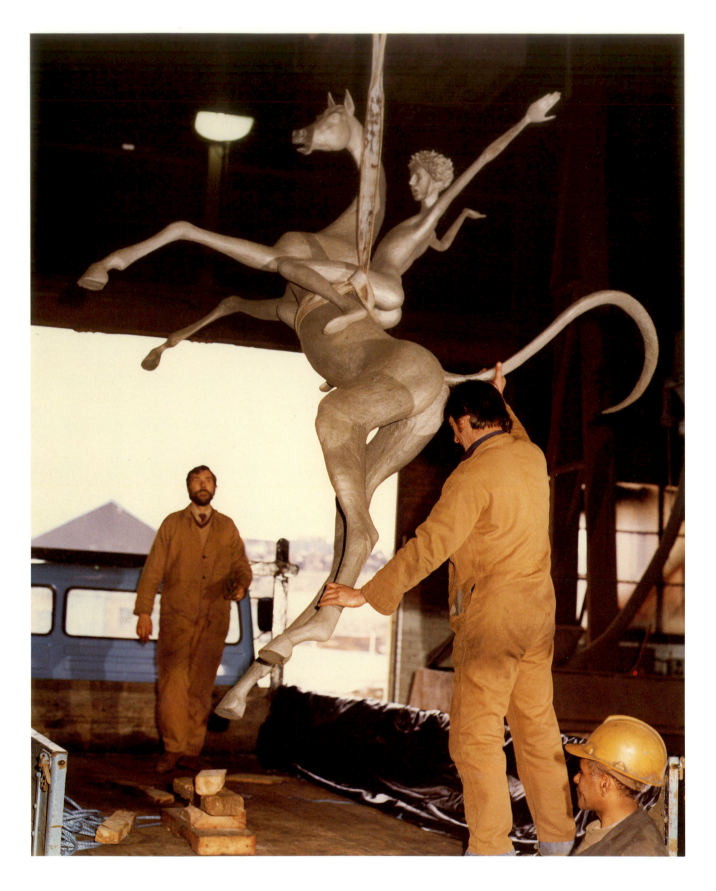

Stainless steel was invented in Sheffield, and so was appropriate.

It is very strong, so that thin and tenuous forms could be used.

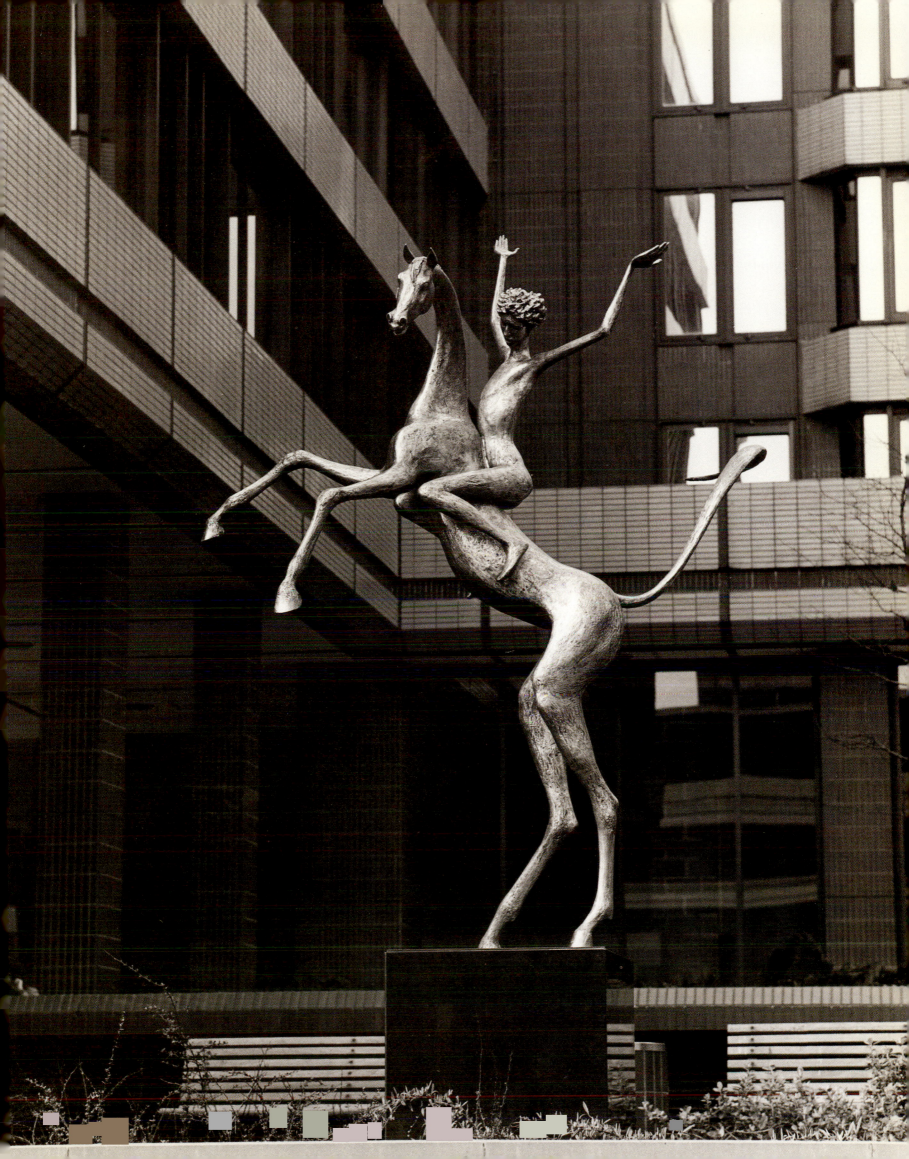

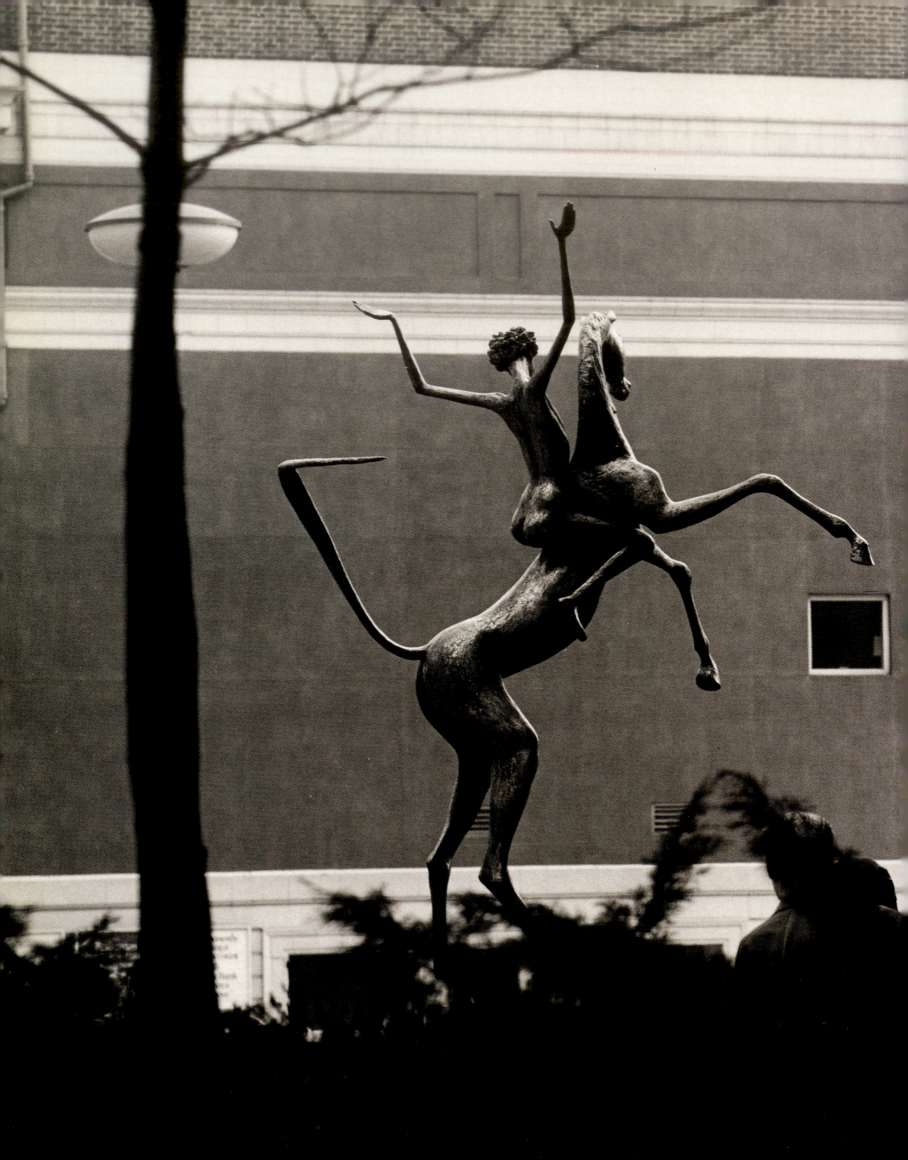

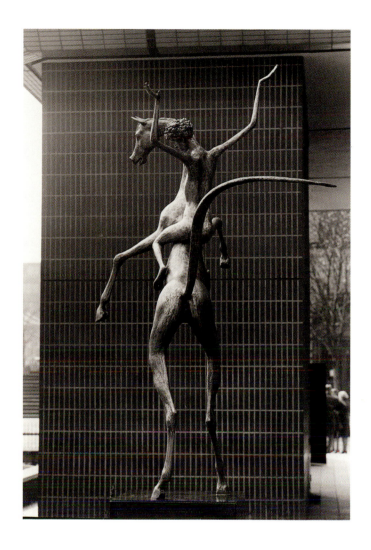

Sheffield is a manufacturing town,
and there is little to relieve the
utilitarian grimness of the streets.
The sculptor strove to make
something wild and wonderful,
a glimpse of freedom and joy.

1979

Bowood Figure

NEBRASINA MARBLE, 96"

Bowood House, Wiltshire

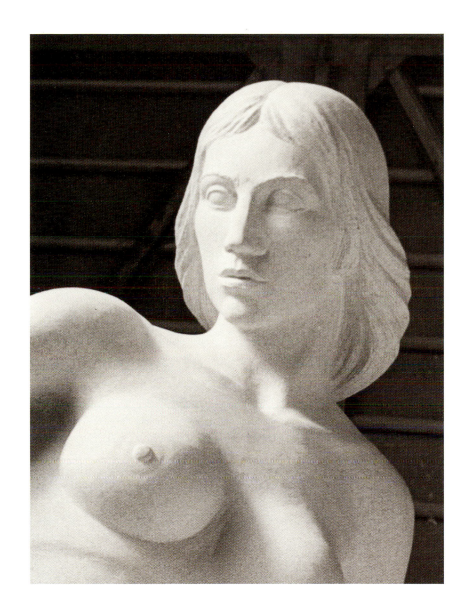

Detail of *Bowood Figure*

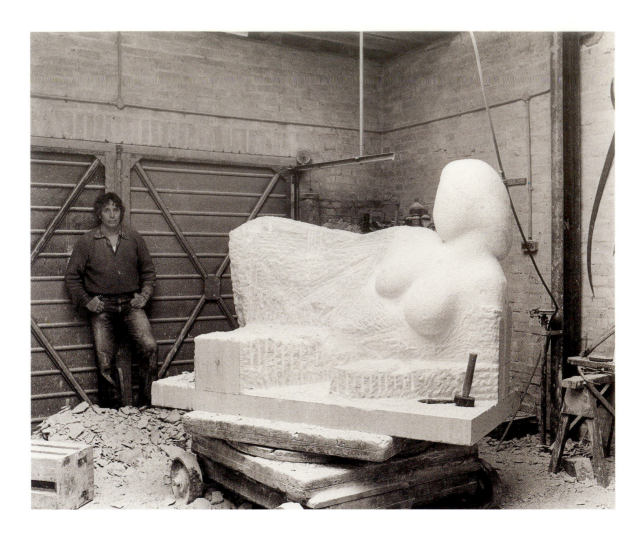

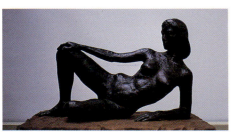

Nicola, the sculptor's stepdaughter, was the model for this work.

It was carved with the help of Derek Carr, who worked with the sculptor on all the later carvings in the Wimbledon studio.

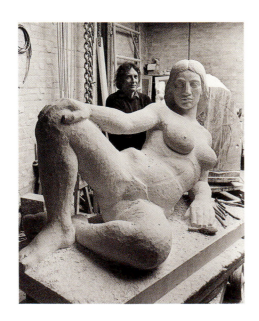

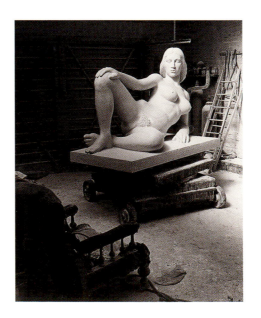

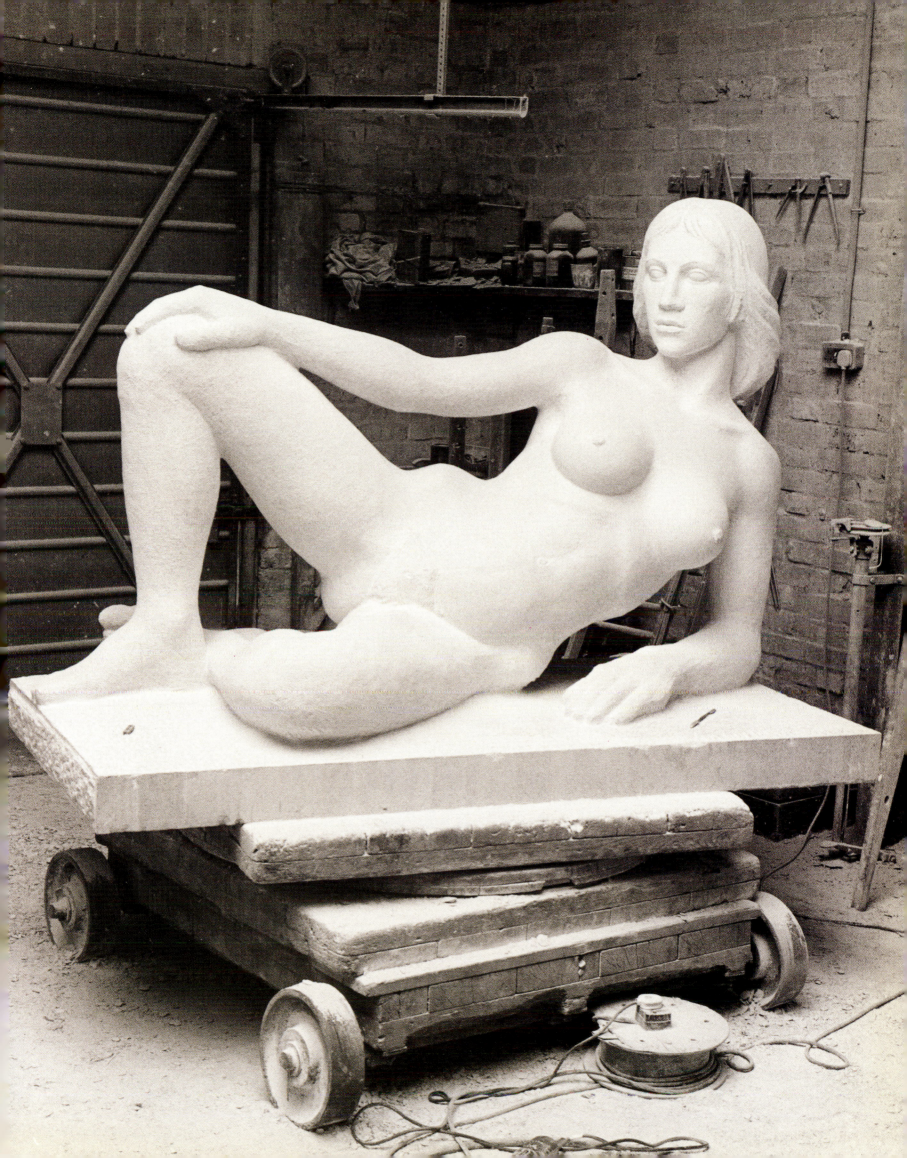

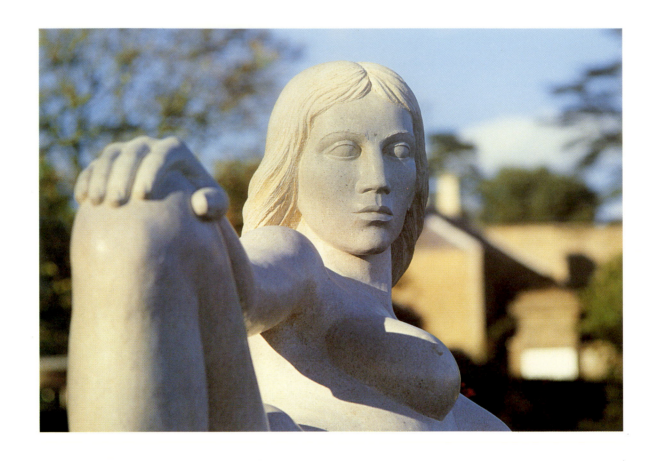

The carving was to replace an 18th century
stone Neptune which had crumbled away.
The pose is tranquil and simple.

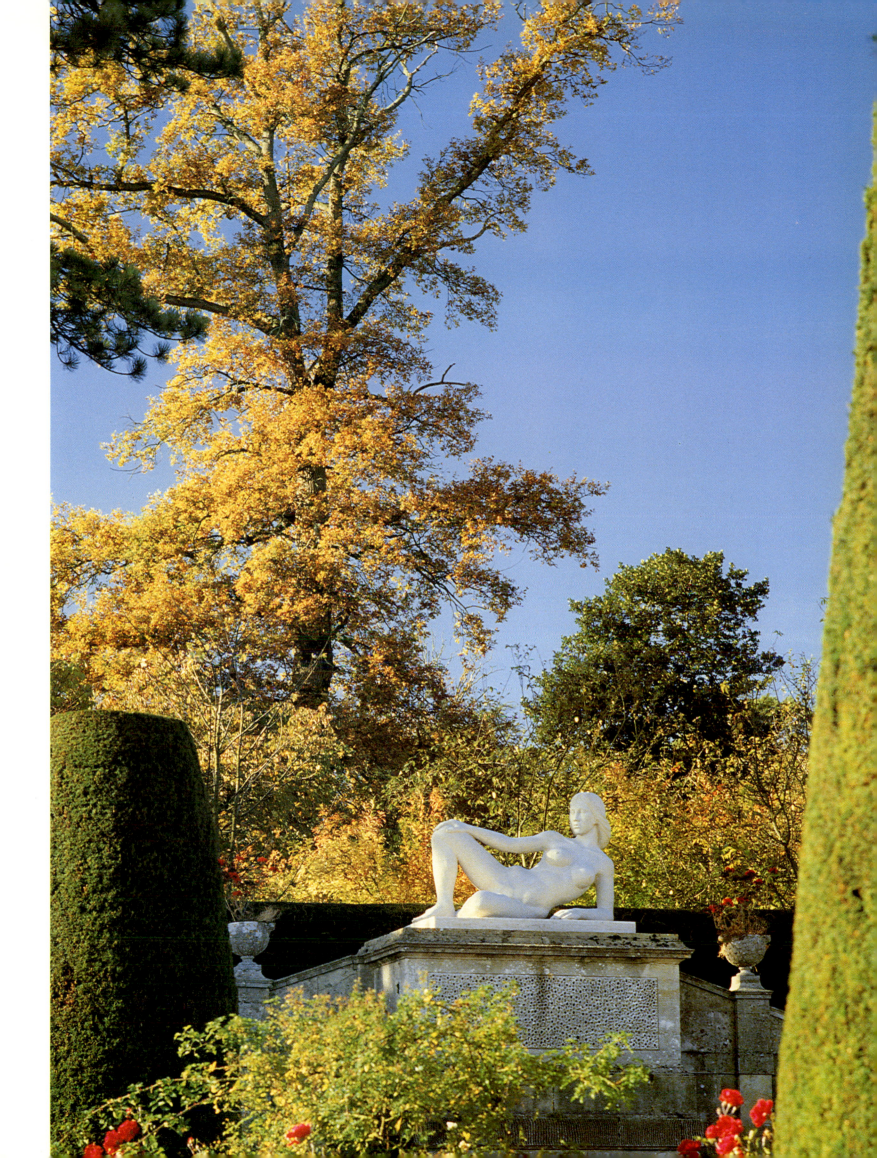

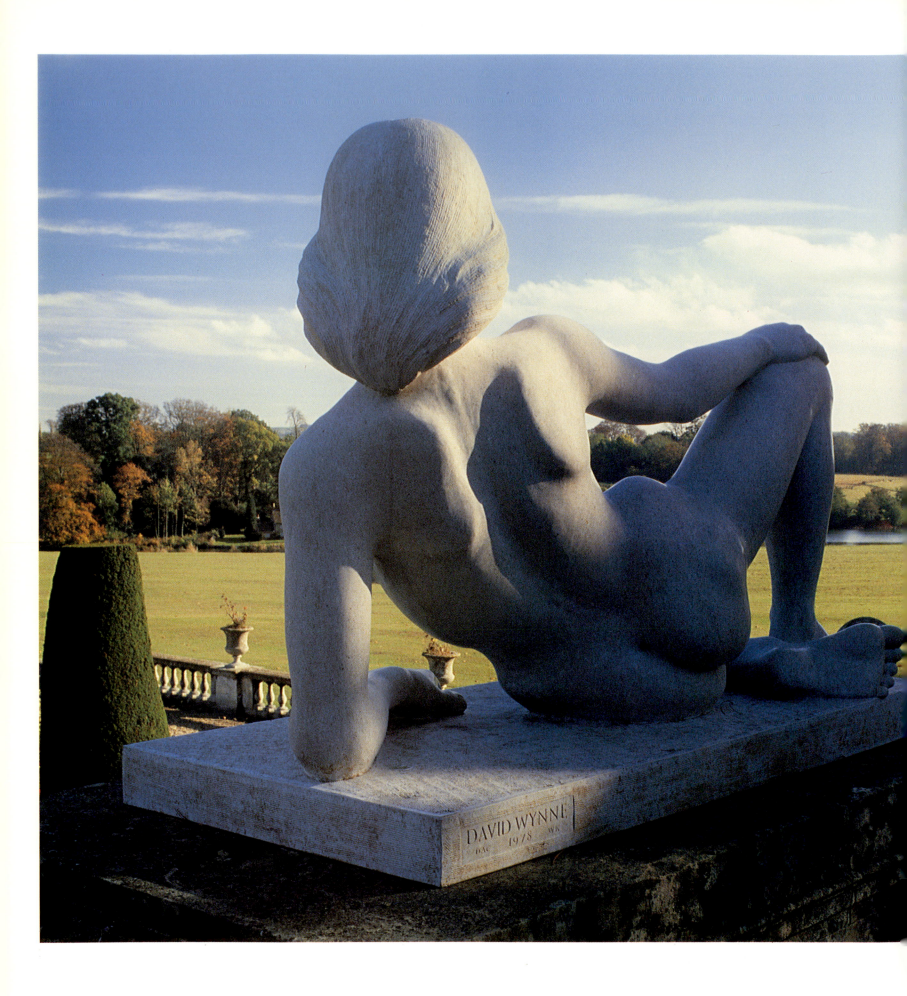

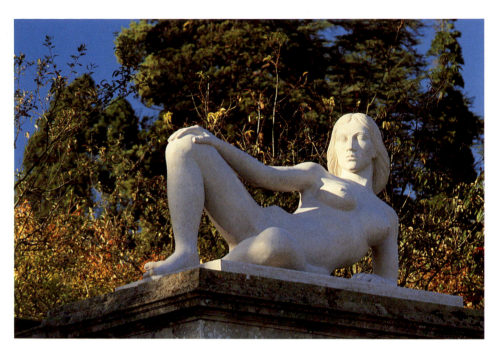

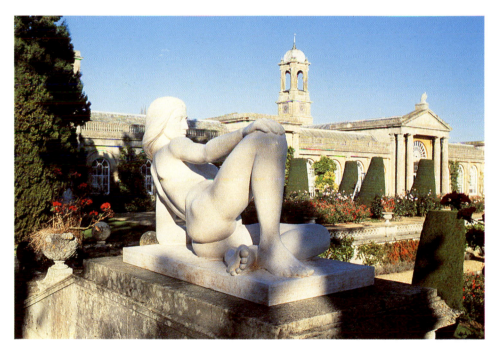

Like a calm goddess she gazes
over the rich English landscape.

49

1980

Leaping Salmon

STAINLESS STEEL, 72″

Kingston House, Kingston-upon-Thames

BRONZE, 72″

The Meadows, Sarasota, Florida

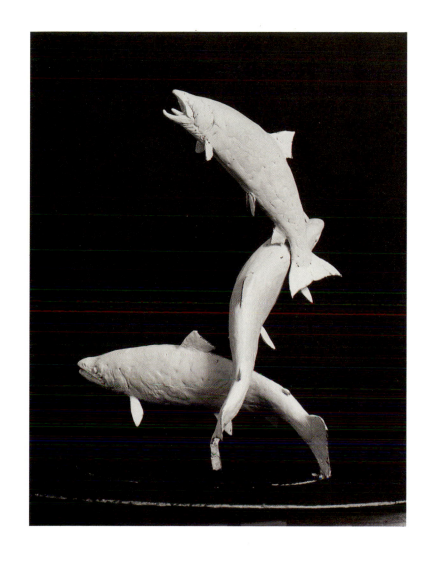

Maquette of *Leaping Salmon*

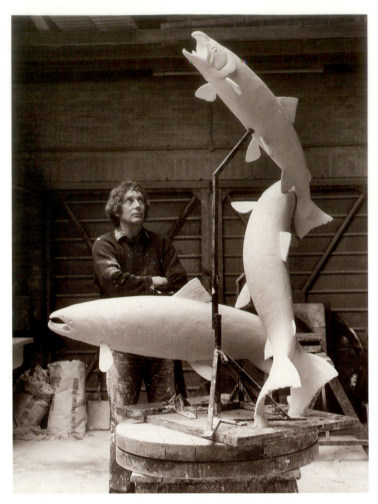 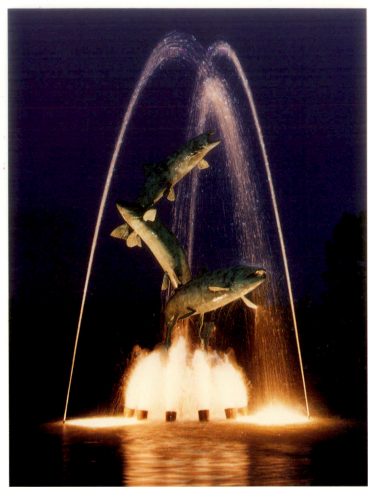

The sculptor went to Galway to study salmon,
and spent many wet hours watching them leaping.

The big male has threatened the smaller cock fish,
while the hen turns away. Three salmon is
the ancient insignia of the town of Kingston-upon-Thames.

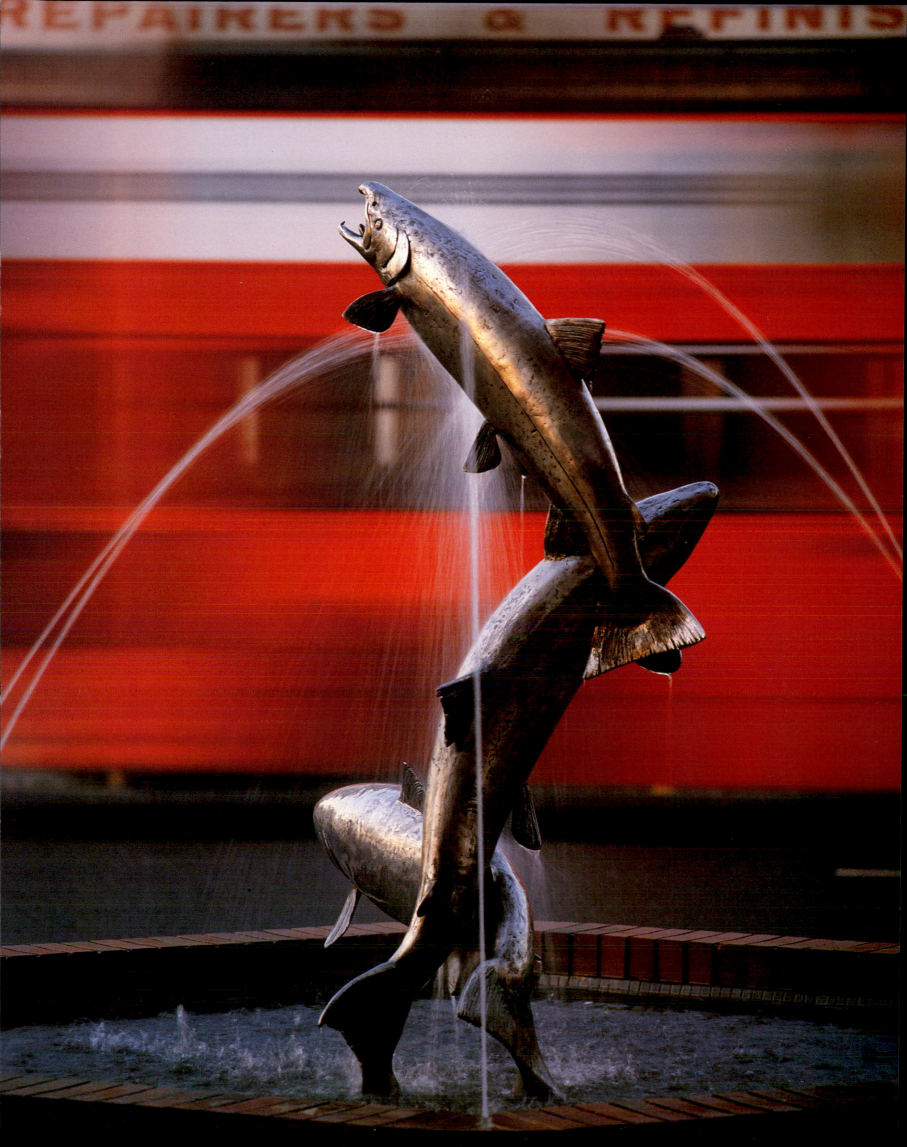

1981

Two Swimmers

BRONZE, 138″

Board Walk, Atlantic City, New Jersey

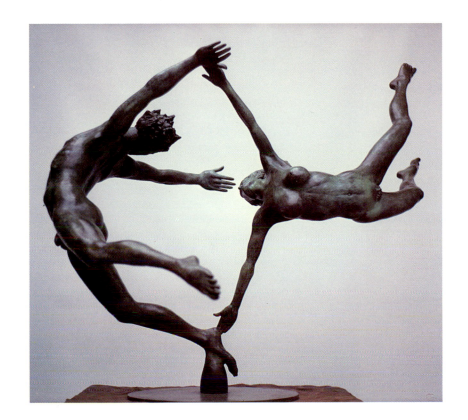

Two Swimmers: maquette

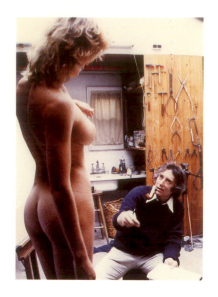 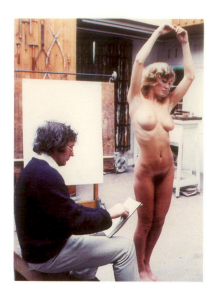

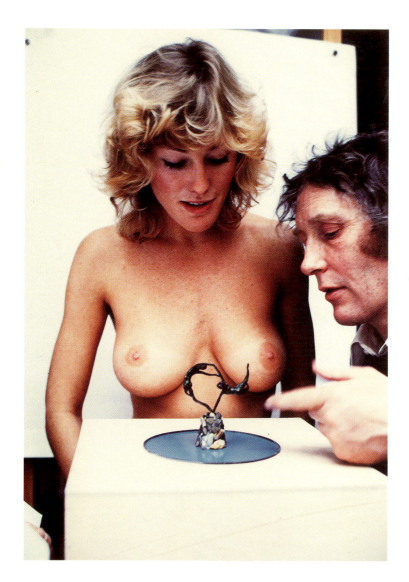

The commission was for a large fountain sculpture, to incorporate a female figure and to stand outside the Playboy casino in Atlantic City. Victoria, who posed for it, came over from California at my request; my stepson Jonny was the model for the male figure.

This is a complicated and subtle group where the two literally balance one another. The whole sculpture rotates slowly as the water plays on the forms. Many weeks of study and thought were necessary before the large plasters were made.

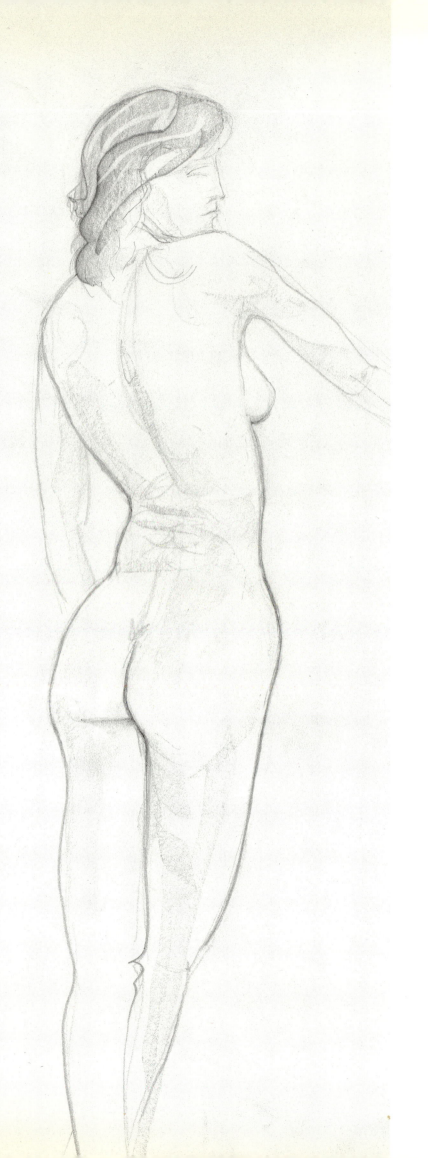

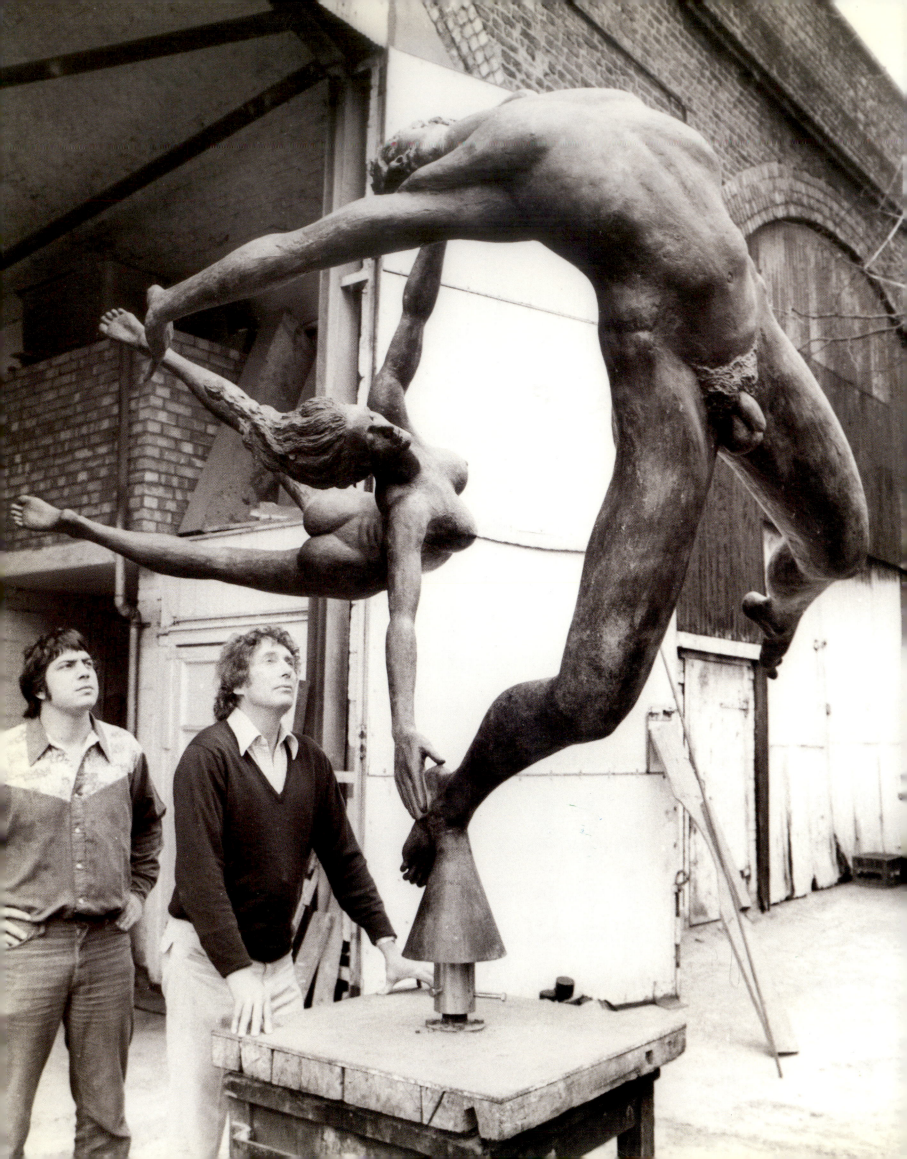

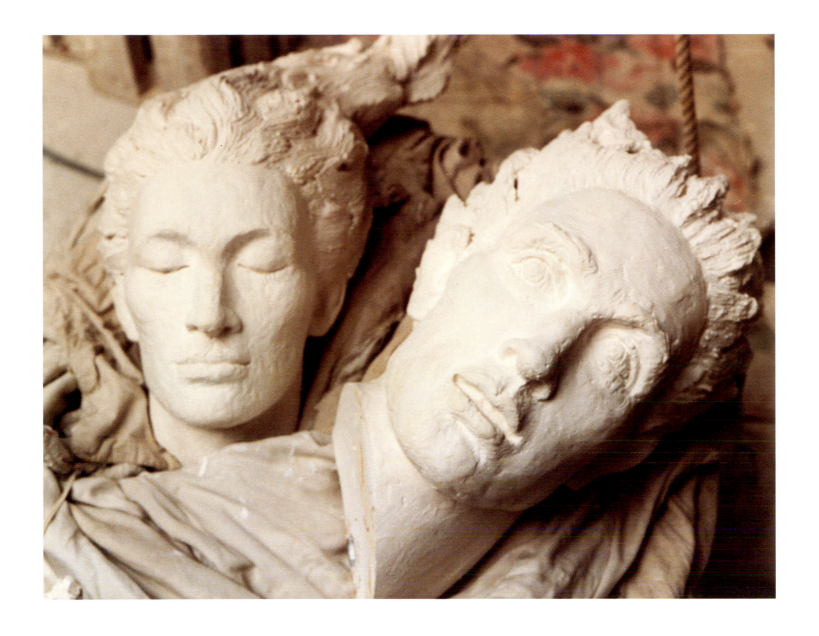

Jonny and his father assess the casting at the foundry.

She swims by him, eyes closed and totally self absorbed.

He turns and strains to let her pass.

He is like a bow, her arms the string, and her body the arrow.

In one sense he is breaking himself to let her fly free.

Above, the plaster heads waiting to be moulded,

closer than they will ever be again.

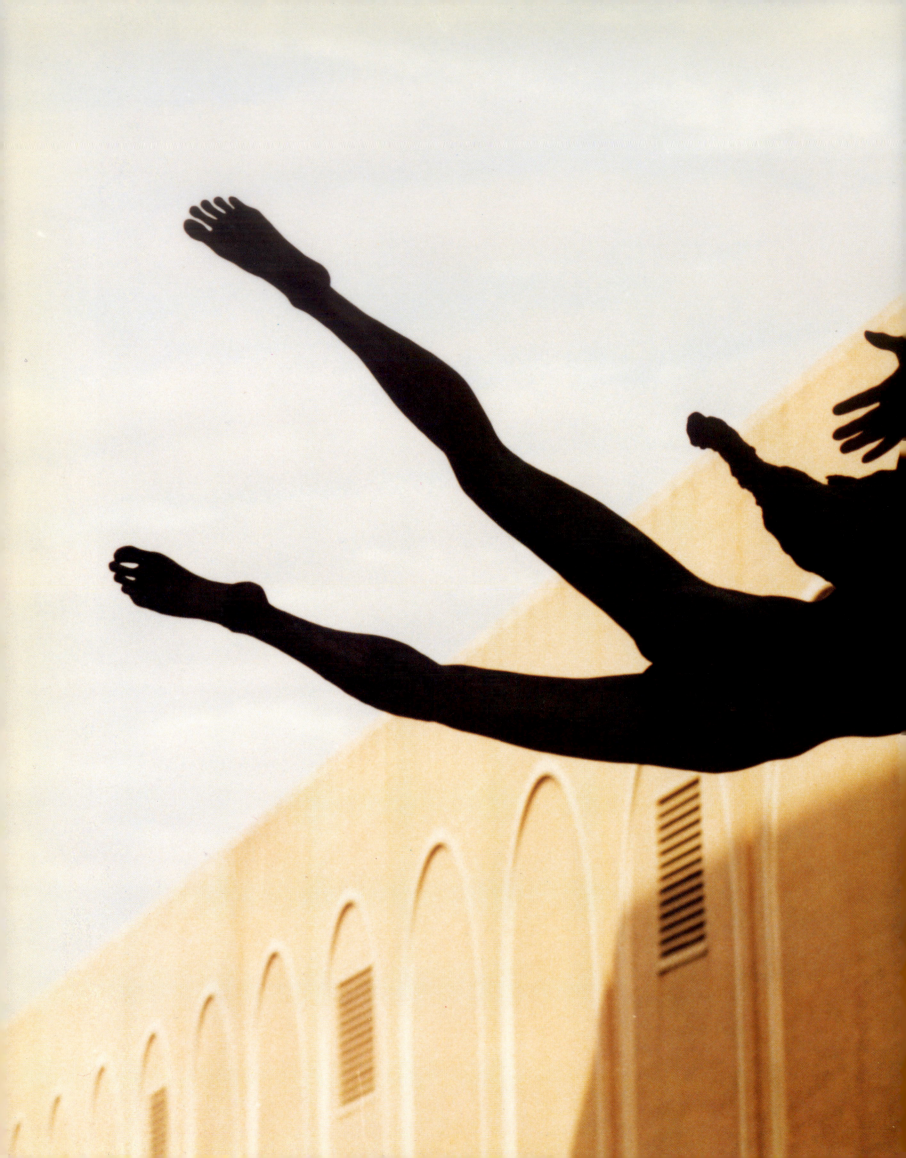

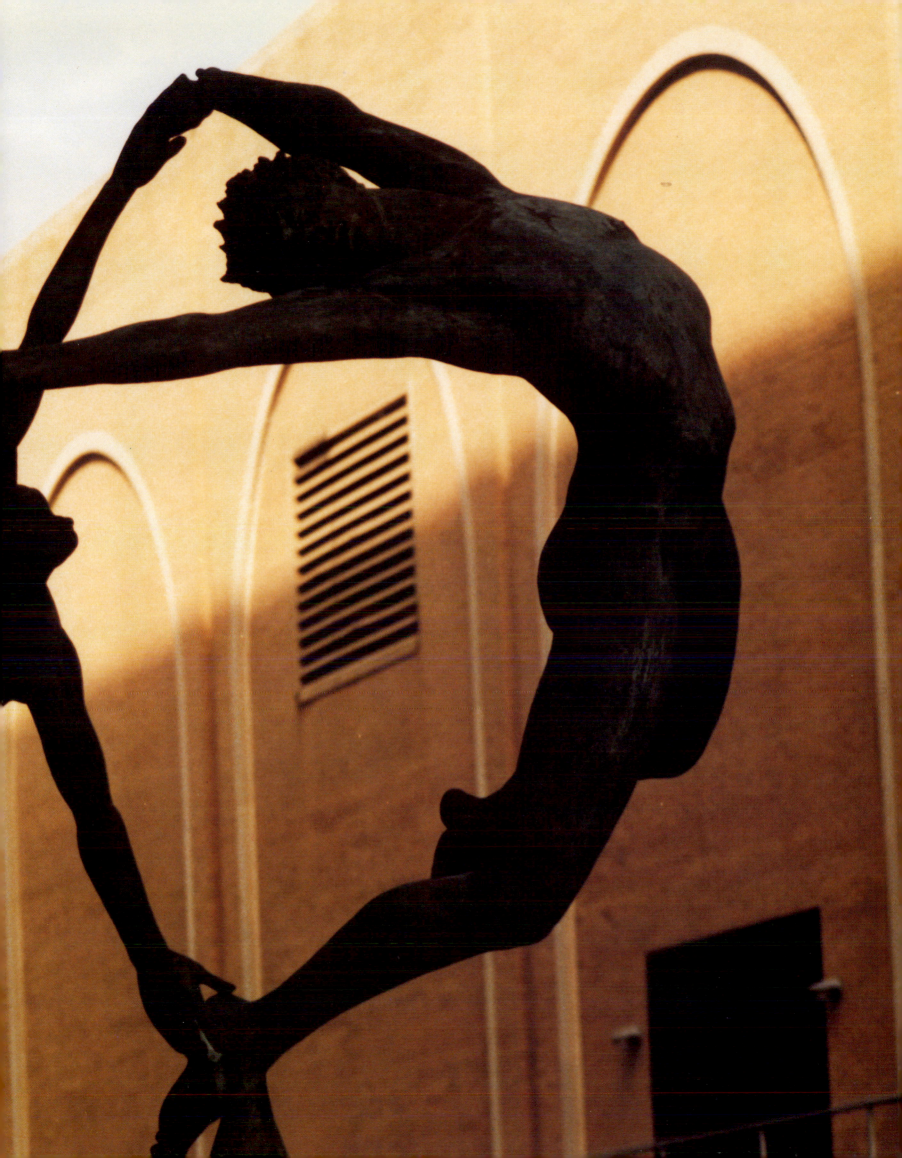

1982

The Messenger

BRONZE, 150″

IPC Headquarters, Quadrant House, Sutton, Surrey

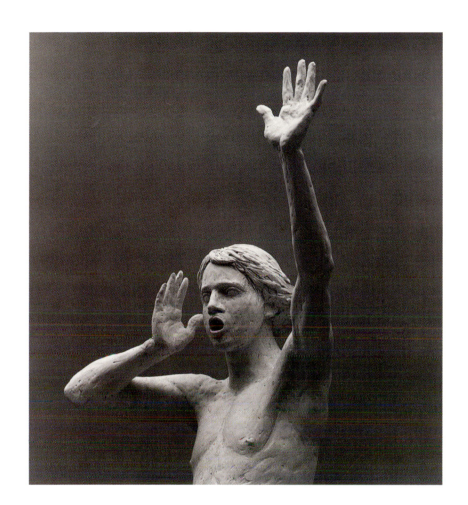

Detail of *The Messenger*, maquette

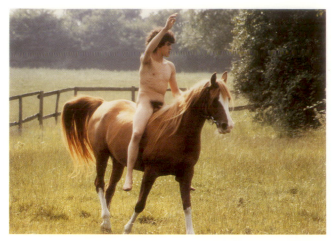

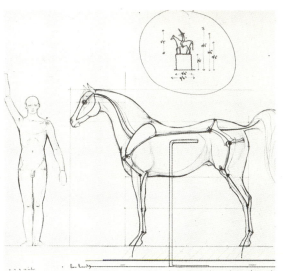

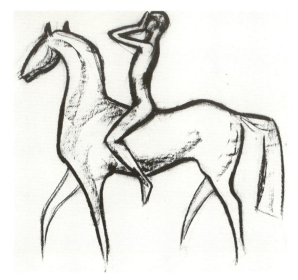

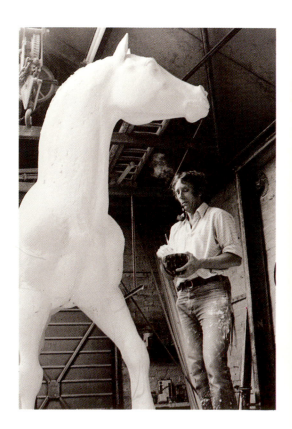

Before starting this commisson the sculptor travelled
to Rome and Venice to see the Marcus Aurelius and the
Four Horses of St Marks, to draw inspiration from
the great masterpieces of the past.

After prolonged study of Arabian horses at the Milla
Lauquen Stud he made the maquette.

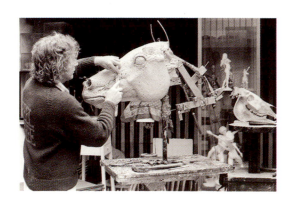

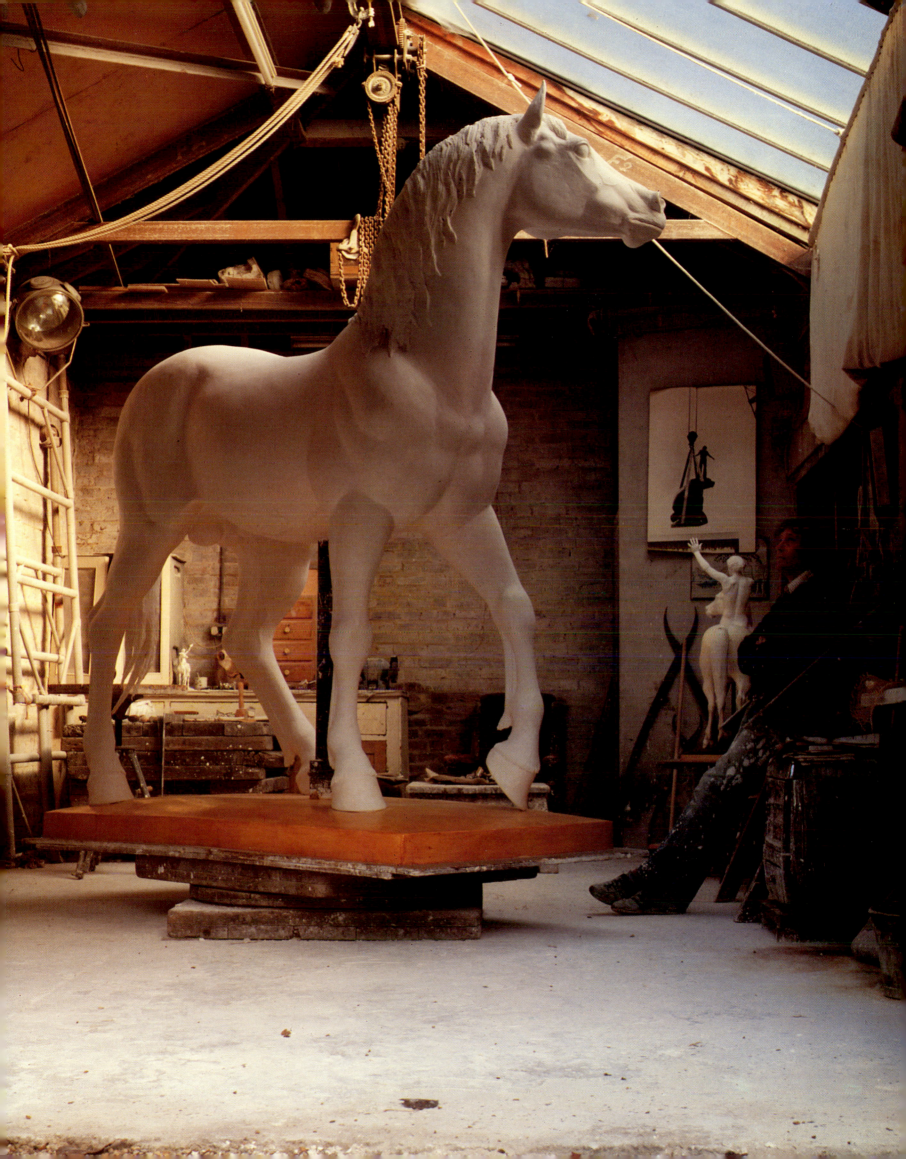

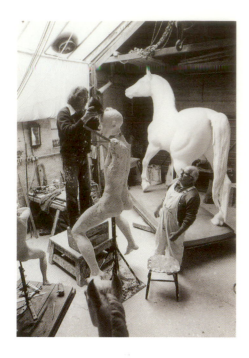
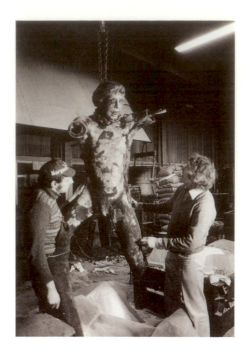
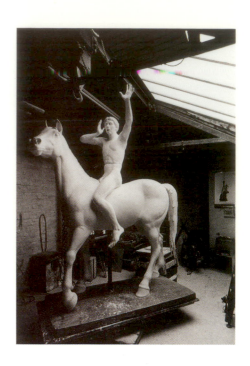

It seems sometimes that a sculptor's ideas and
his vision have to be made and destroyed many
times before the work is complete.

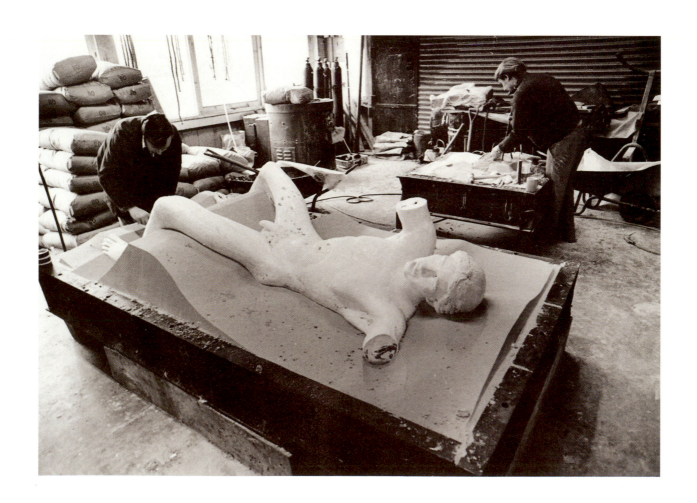

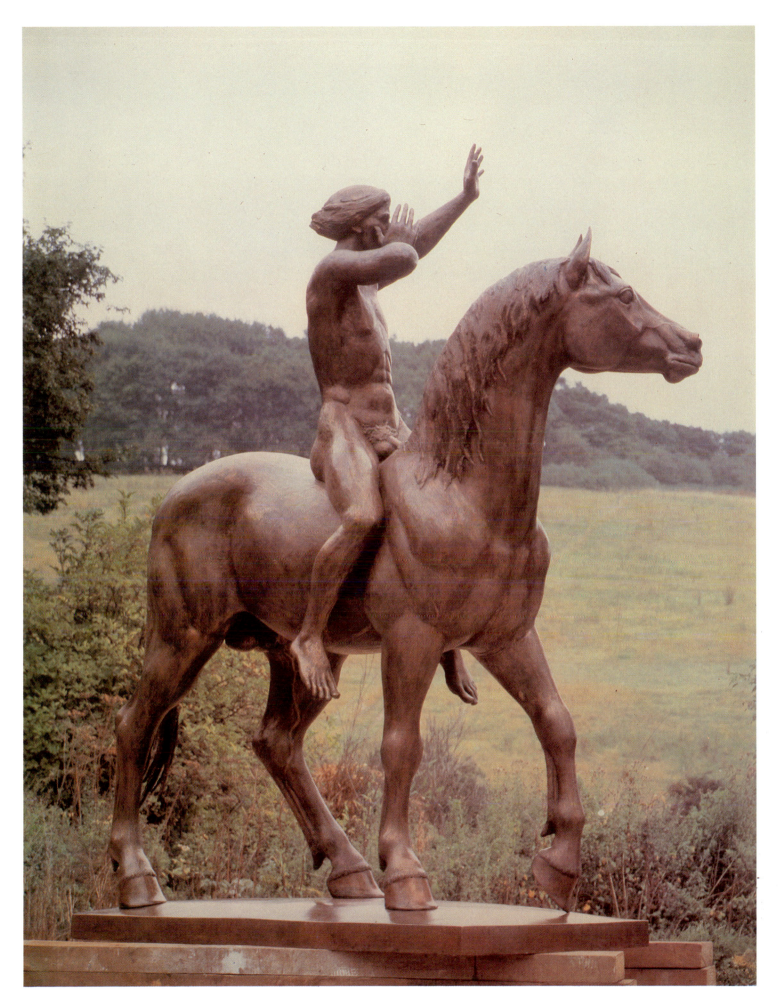

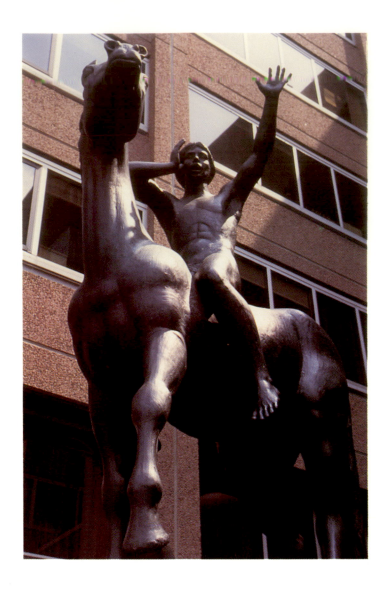 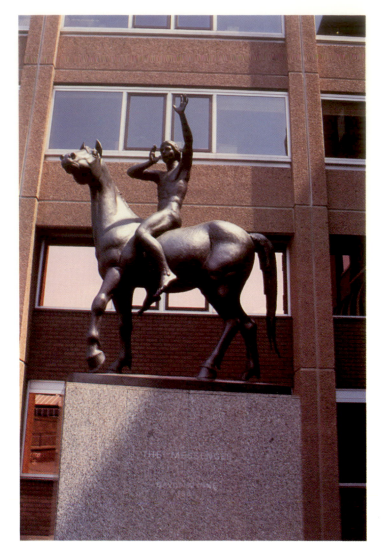

The brief given to the sculptor was 'communication'.
To him this meant the passing of a message, an urgent call
from one to another, the eternal cry of our inmost being.
'Wake up, remember!' There is another reality, a place that
children know, but one that we turn from when the material
world seems so real to us. Then we forget it altogether.

But still in dreams the horseman comes. He pauses
for a moment, his wild horse pawing the ground, soon to
plunge on, and the boy calls to the reapers in the valley,
'Remember: Now, before it is too late.'

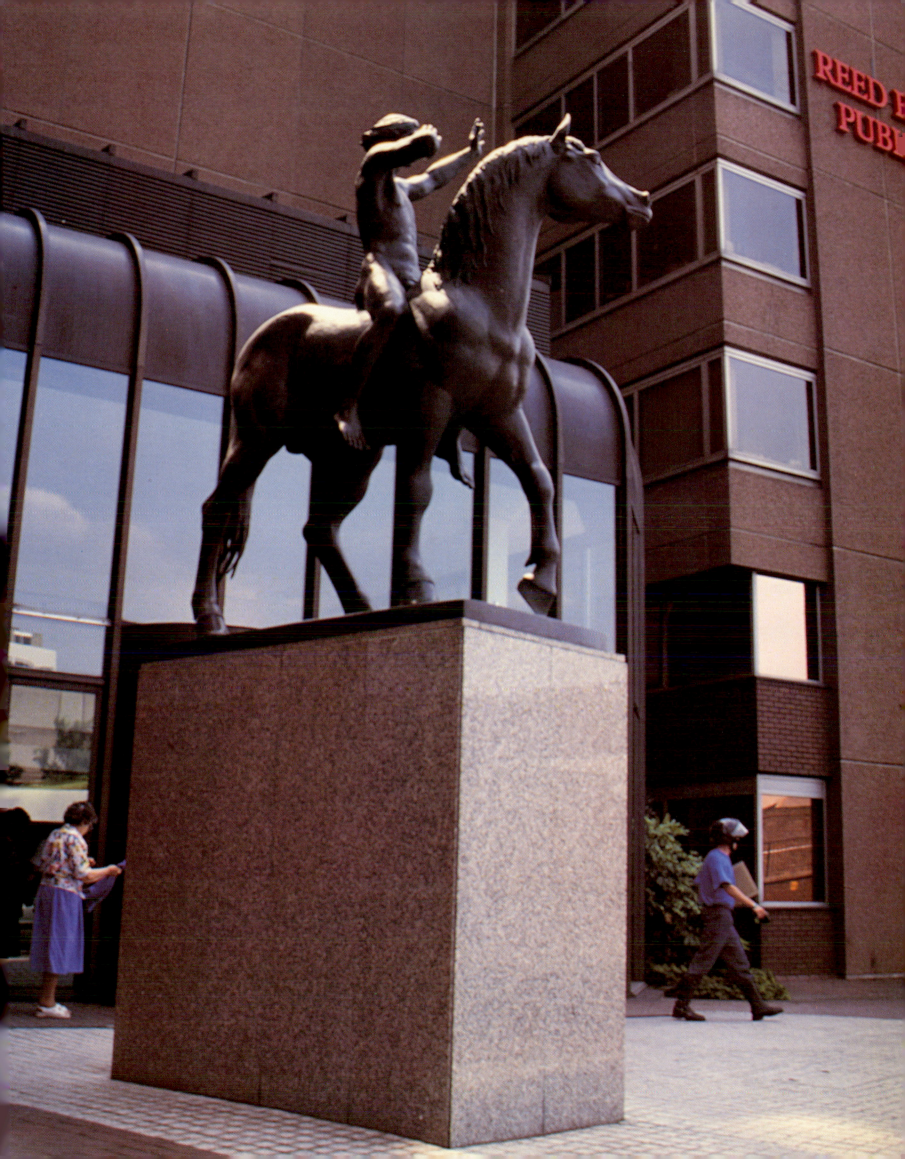

1985

Cresta Rider

BRONZE, 72″

St Moritz, Switzerland

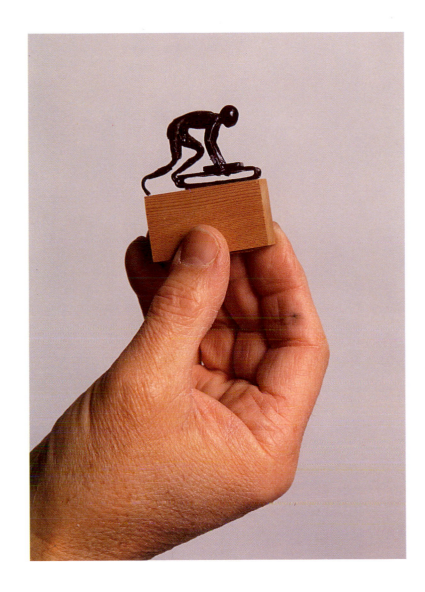

Cresta Rider, small maquette

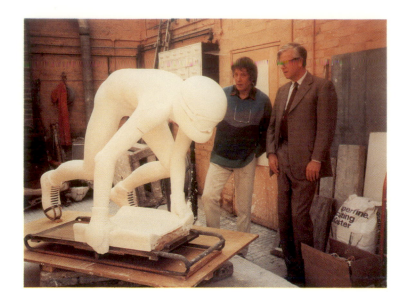

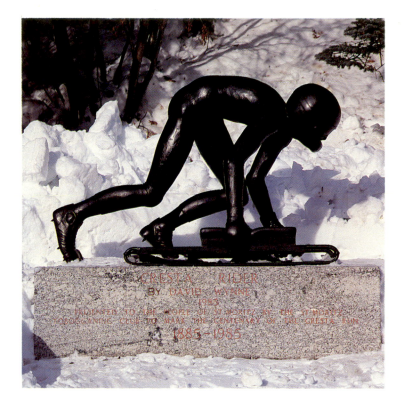

This bronze was made to celebrate the
100th anniversary of the Cresta Run.
It shows a rider at the top of the run, about to
plunge down the mile-long tunnel of ice.

Roger Gibbs, President of the St Moritz
Tobogganing Club, examining the plaster.

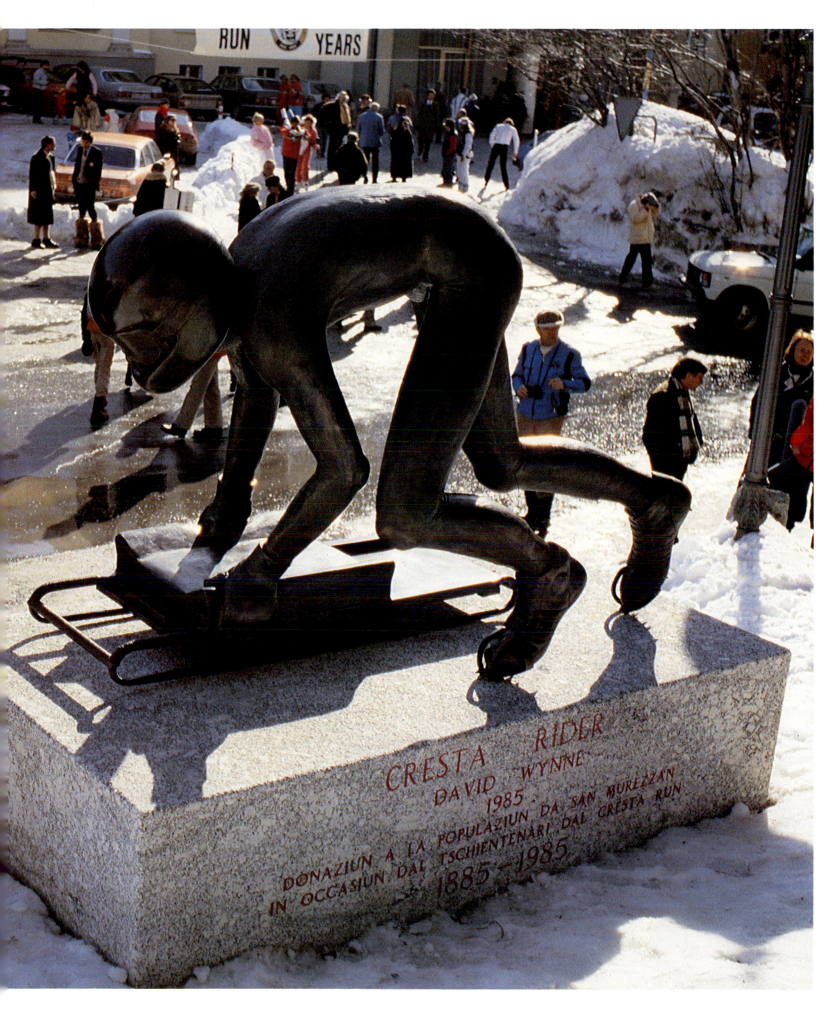

CRESTA RIDER
DAVID WYNNE
1985
DONAZIUN A LA POPULAZIUN DA SAN MUREZZAN
IN OCCASIUN DAL TSCHIENTENARI DAL CRESTA RUN
1885–1985

Risen Christ

LIMESTONE, 96″

West Front of Wells Cathedral, Somerset

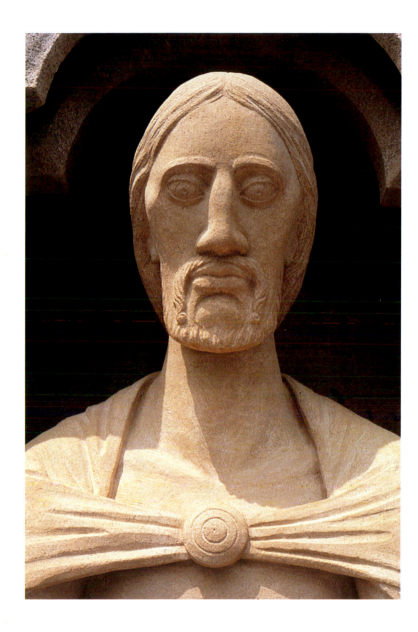

The head of Christ

The starting point was the
fragment of the original Christ.

Both Edward and Roland, sons of
the sculptor, posed for the Christ, and
Jonny his stepson helped with the
initial drilling of the block.

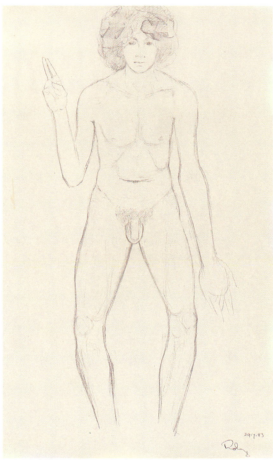

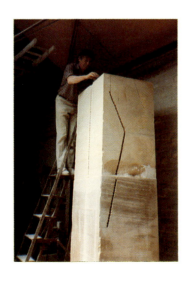

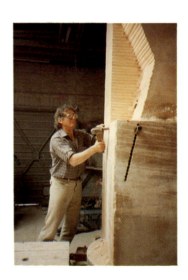

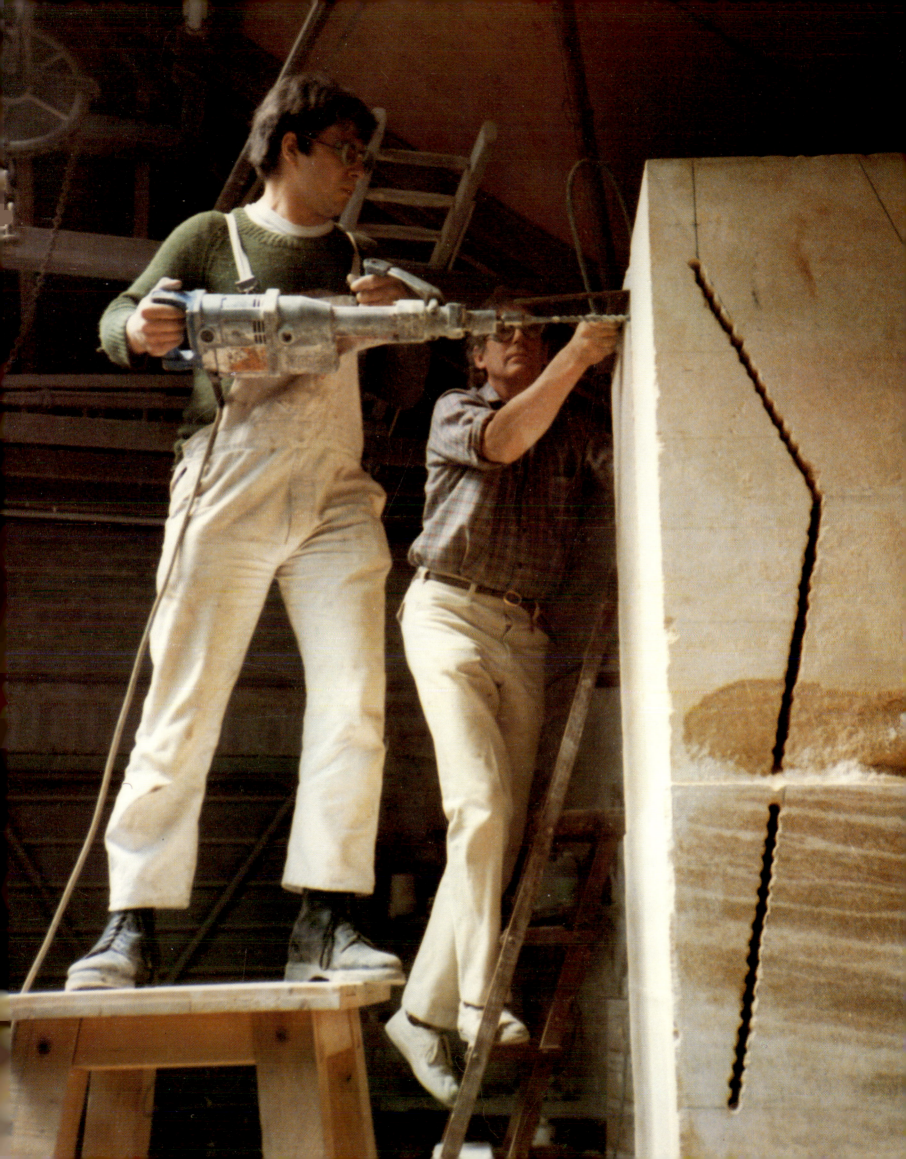

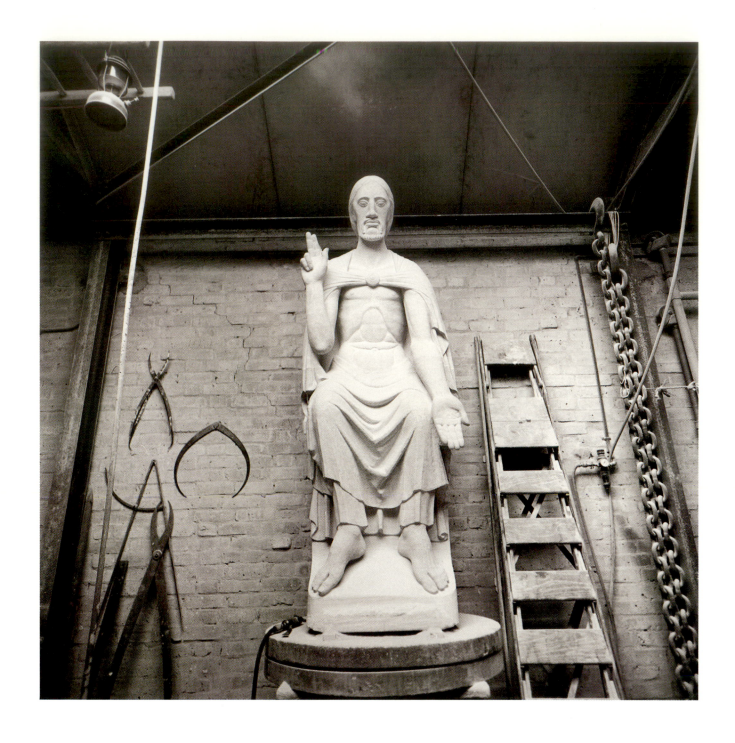

The carving was to replace the 13th century Christ which fell
hundreds of years ago. It had to blend with the apostles, saints
and kings which adorn the West Front of Wells Cathedral,
perhaps the most beautiful façade in all Romanesque art.

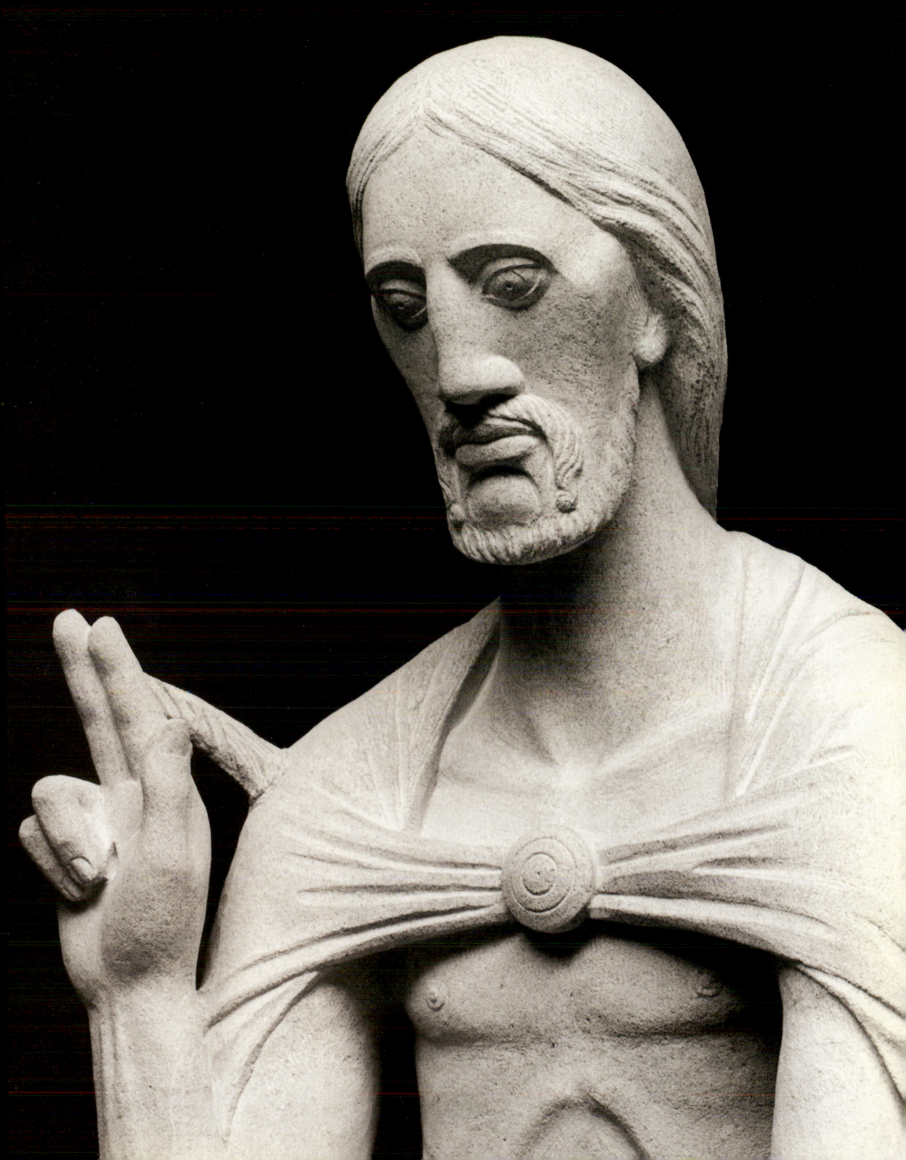

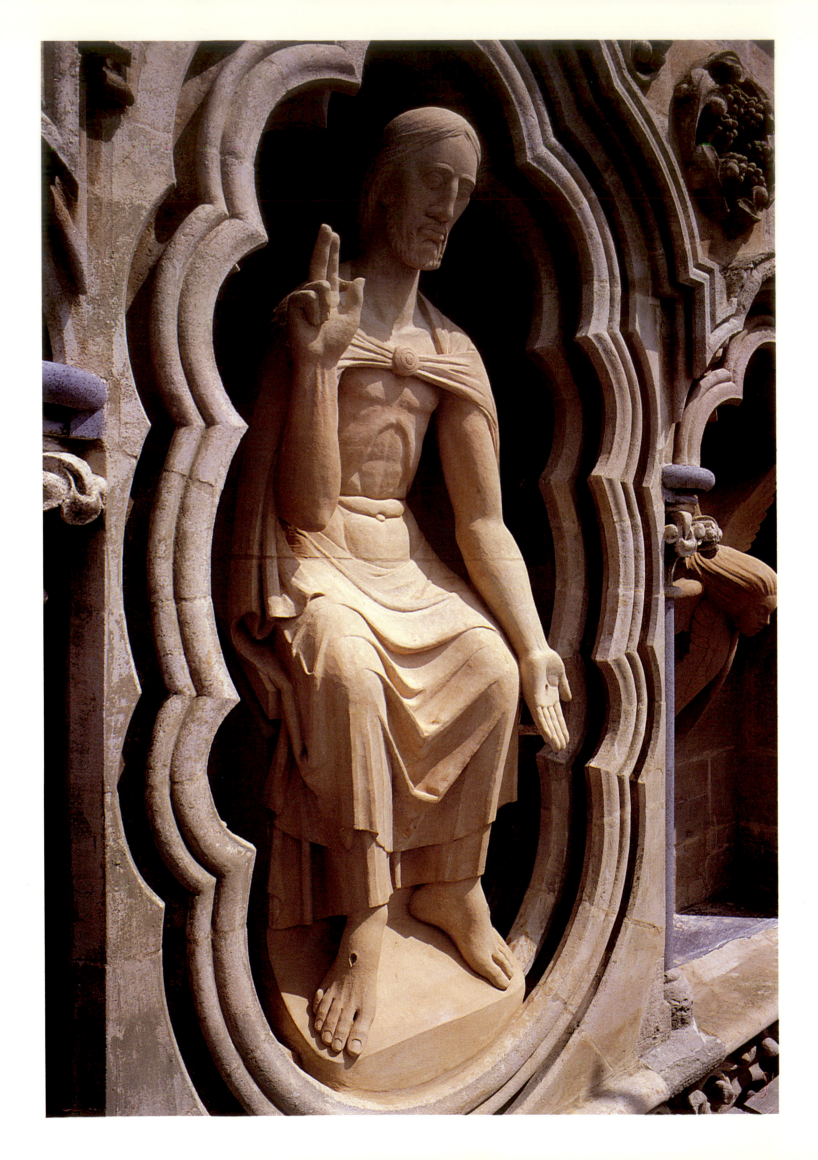

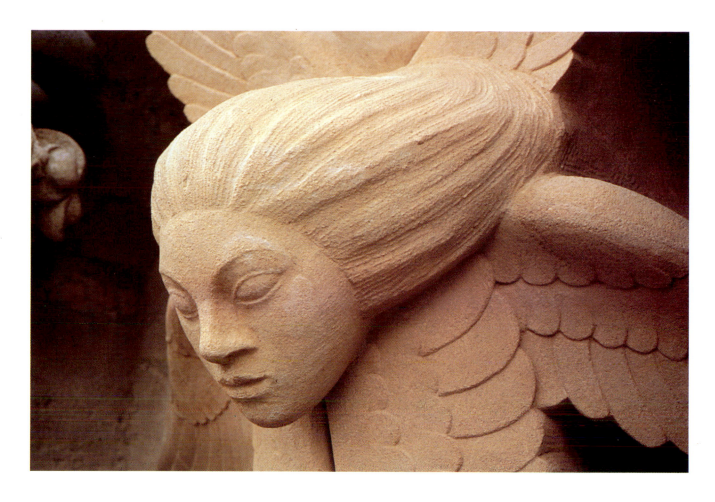

The Christ figure is reaching down:
'Come up to me. You can, now.'

The Seraphim guard him, one to his
left hand and one to his right.

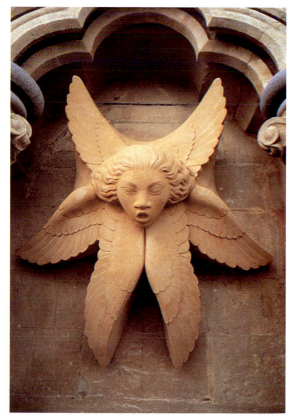

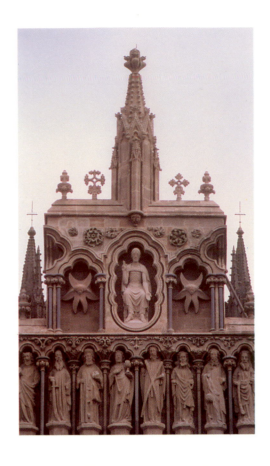

The figures look down from a height
of 90ft onto the Cathedral Green.
Below are the twelve apostles,
and below them again the whole
'Chivalry of Heaven'.

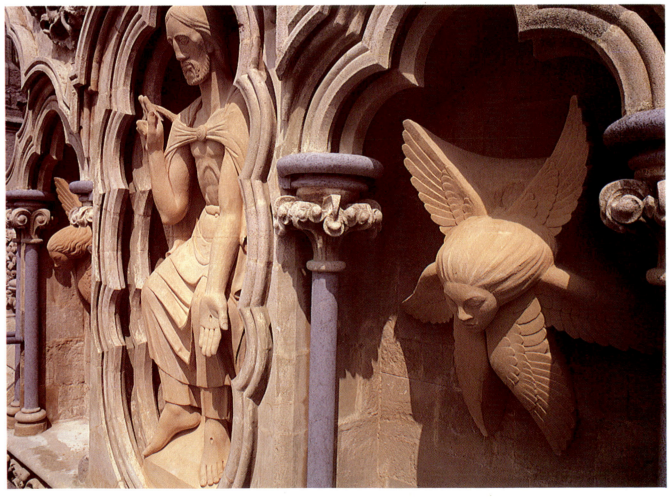

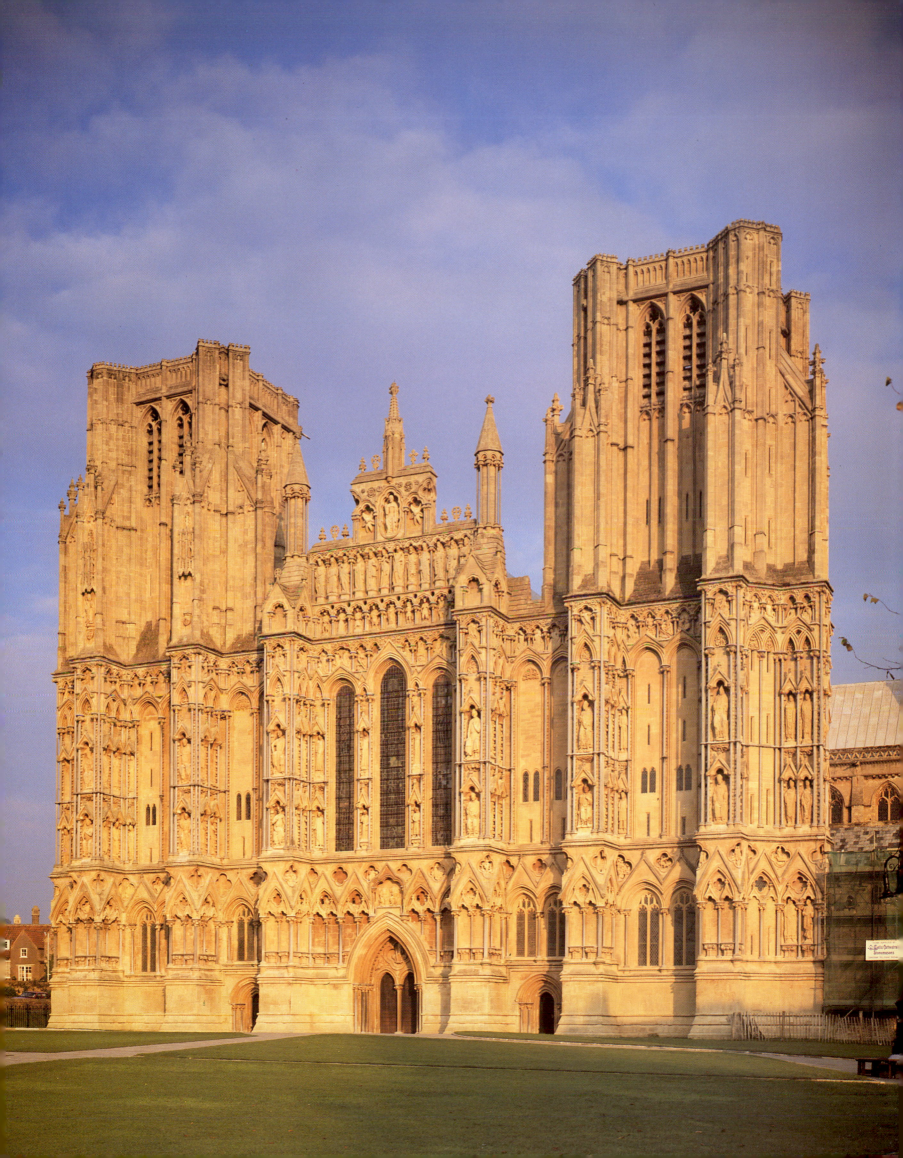

1986

Saint Raphael

BRONZE, 48″

The Hospice of Saint Raphael, Cheam, Surrey

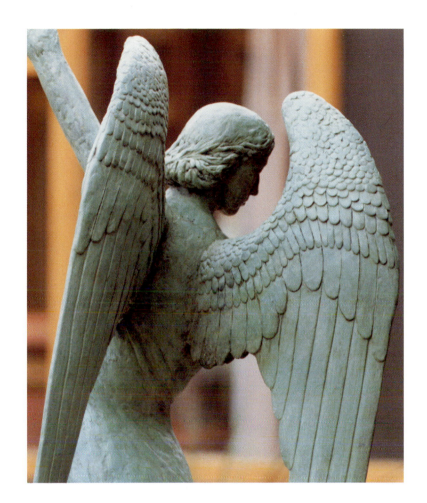

Detail of *Saint Raphael*

The courtyard of the Hospice with the figure
in front of the Chapel. Hospices are founded to allow
people to die in dignity and peace.

Saint Raphael is he who accompanies them on their
journey from this world to the next.

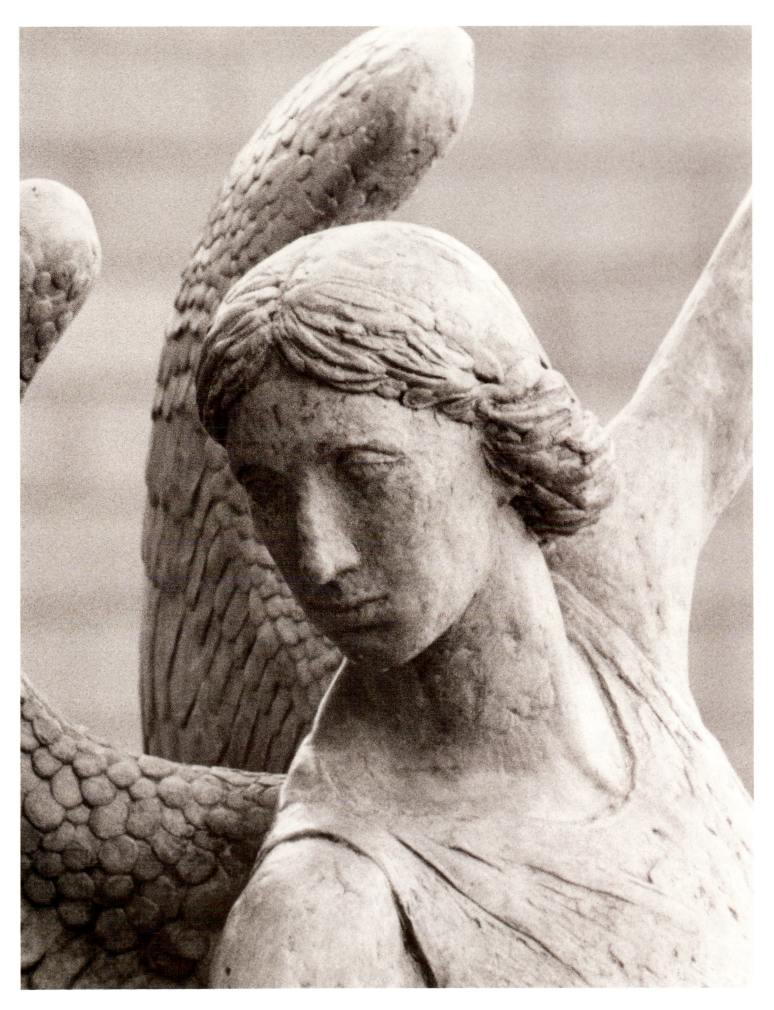

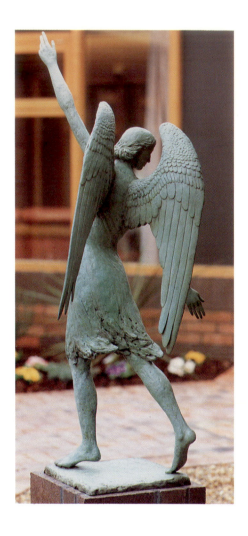
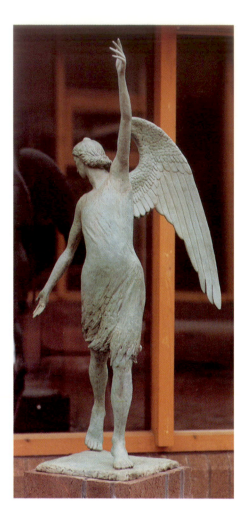
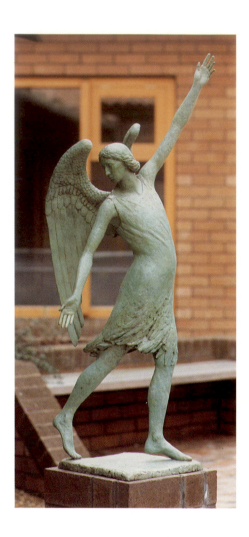

The figure was modelled in clay, whereas
the wings were made direct in plaster.

Sister Mary Perpetua contemplates her
accomplished dream.

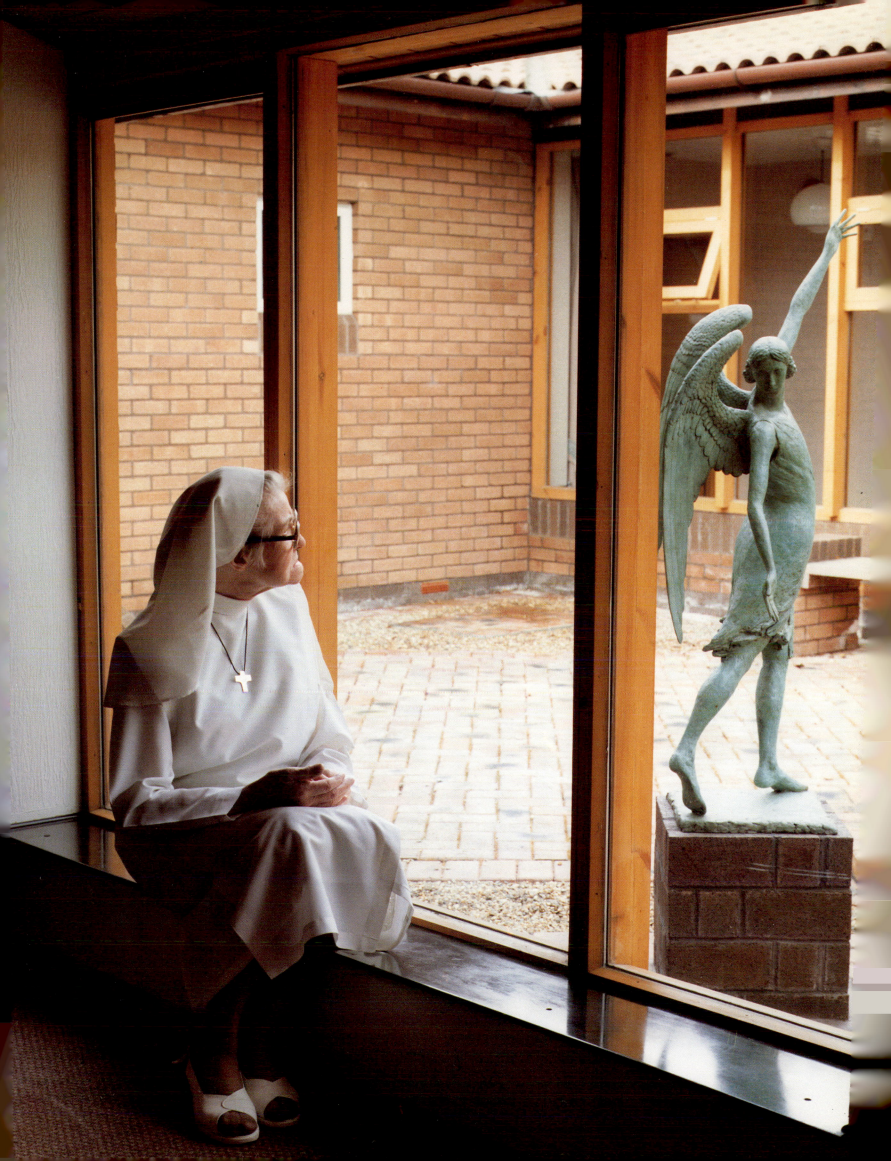

The Awakening Earth

GREEN AND WHITE TURKISH MARBLE, 42″

CBI, Place Camoletti, Geneva

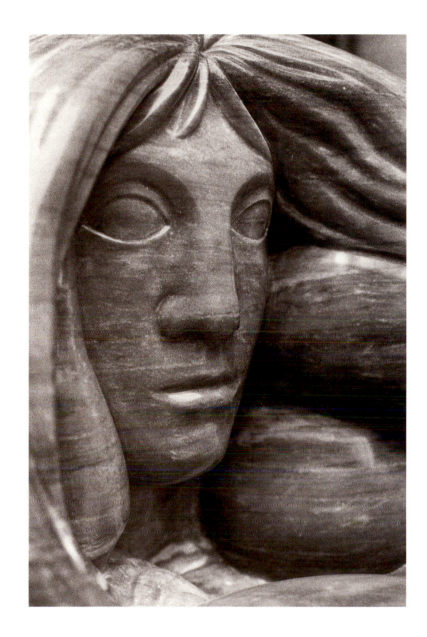

Detail of the unfinished *The Awakening Earth*

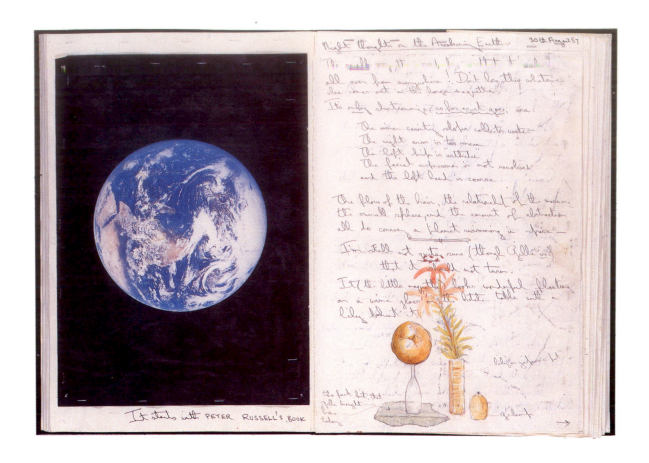

This carving was inspired by a book by Peter Russell,
The Awakening Earth, which propounds the theory
that our world is a living being and can become
sentient at the next quantum leap in evolution.

The sculpture is a green sphere with white clouds
running through, like a planet seen from space.

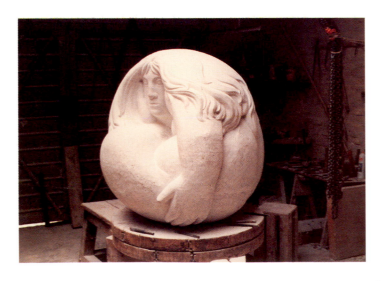

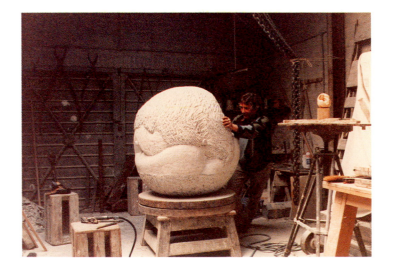

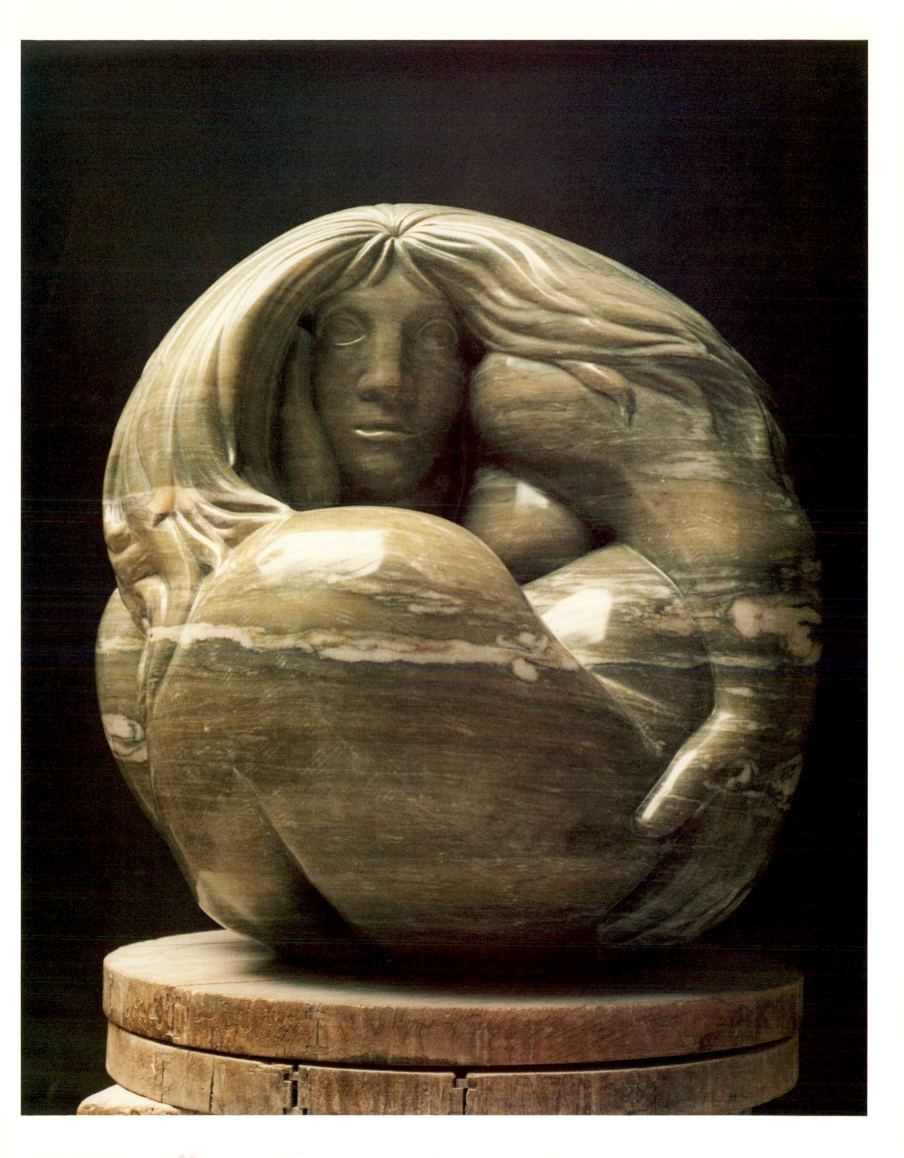

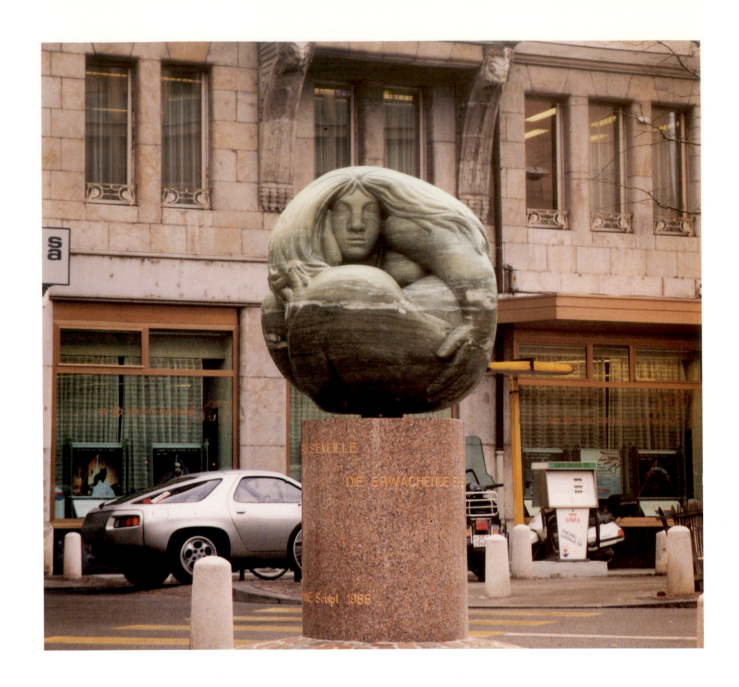

The figure now stands in Geneva, where she gazes over the lake.

Though weighing several tons she can be turned on her pedestal by a touch of the hand.

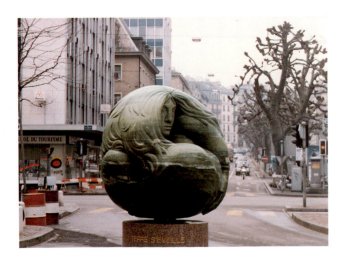

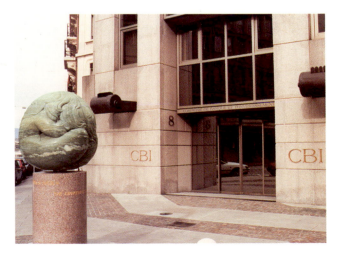

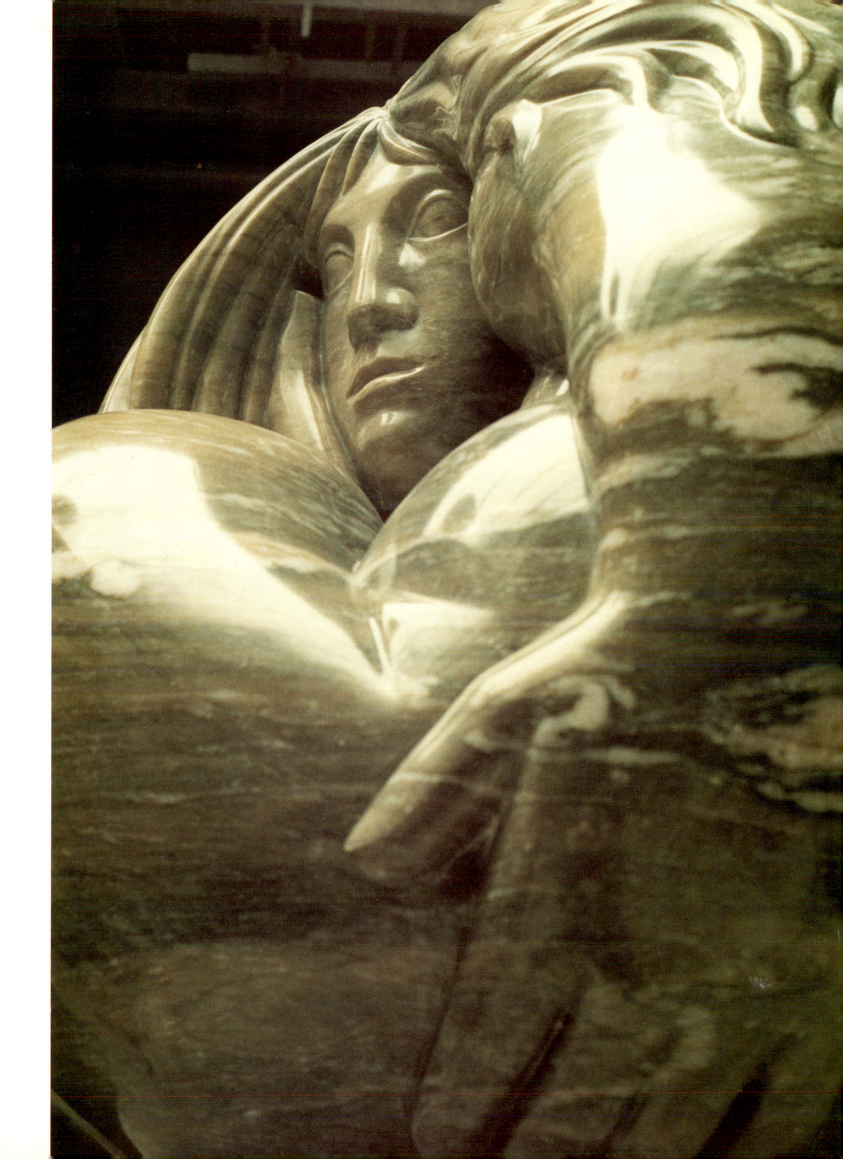

1989

Big Horn Sheep

BRONZE, 51″

Palm Springs, California

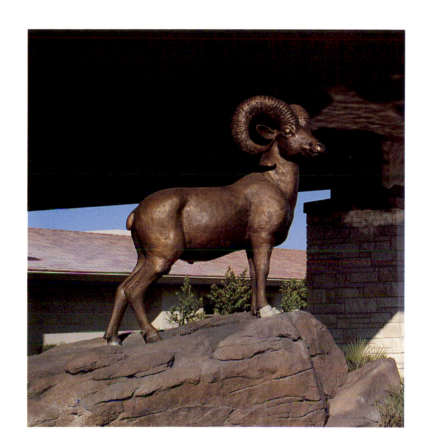

Big Horn Ram

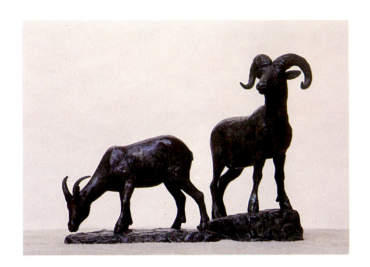

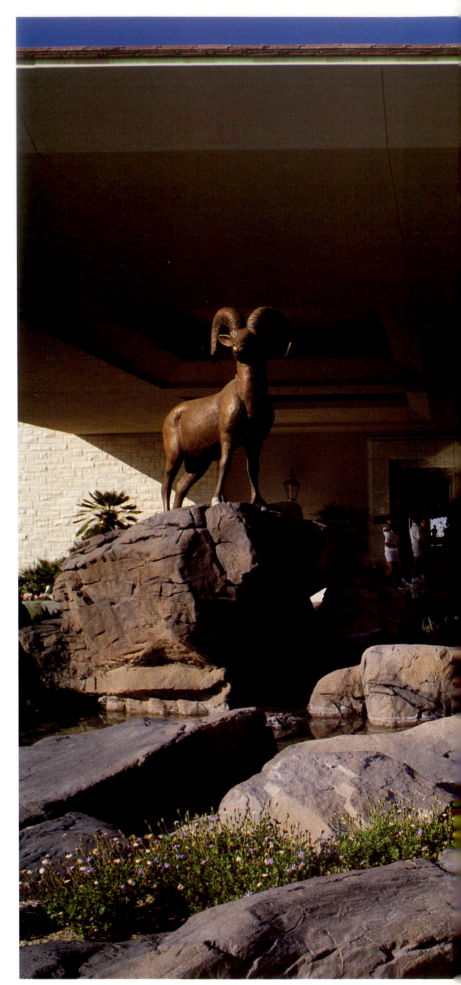

The two bronzes stand in a landscaped
setting outside the Ritz Carlton Hotel, which
is in the mountains beyond the city.

These sculptures portray a rare local subspecies,
a desert animal, which is smaller than
the Rocky Mountain Big Horn.

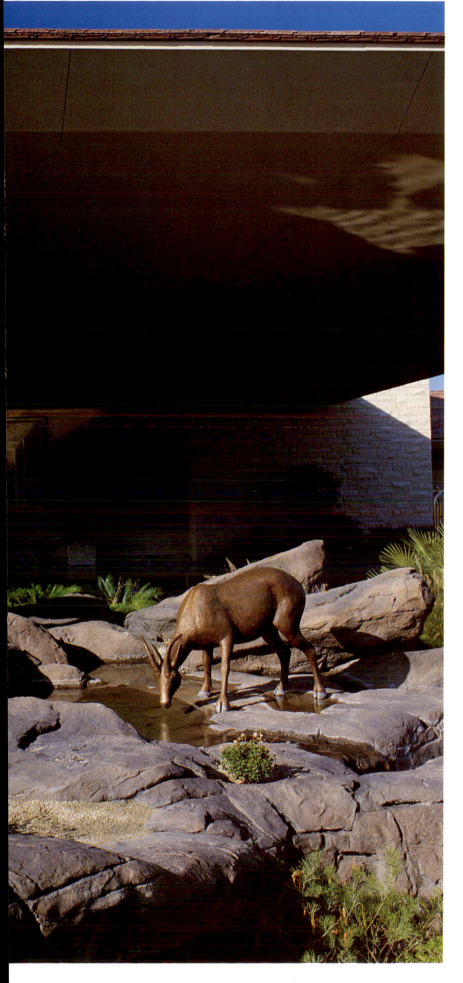

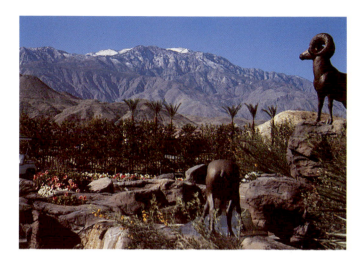

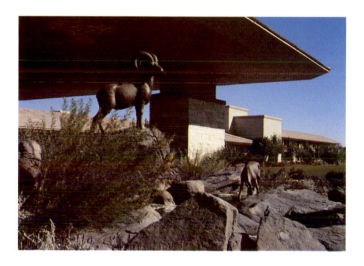

1990

Tresco Children

BRONZE, 120″

Tresco, Isles of Scilly

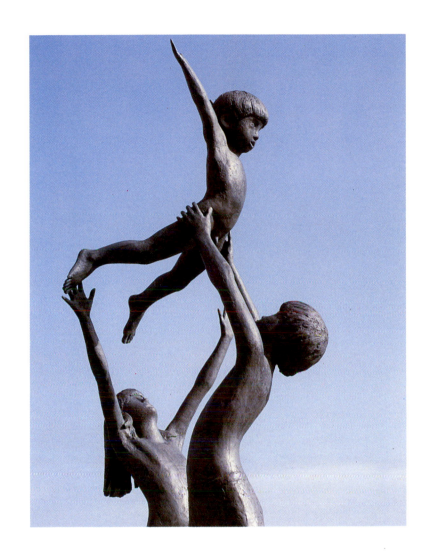

Detail of *Tresco Children*

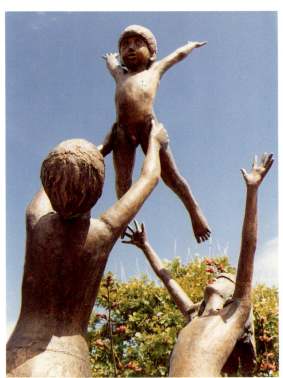

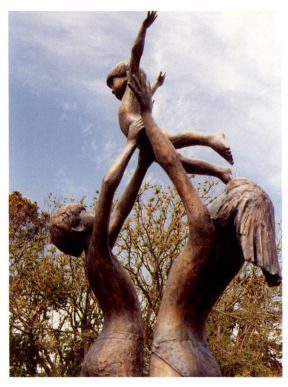

The bronze was designed to be seen from afar as well as near to.
It is a counterpoint to the Gaia carving which is also in the Abbey Gardens.

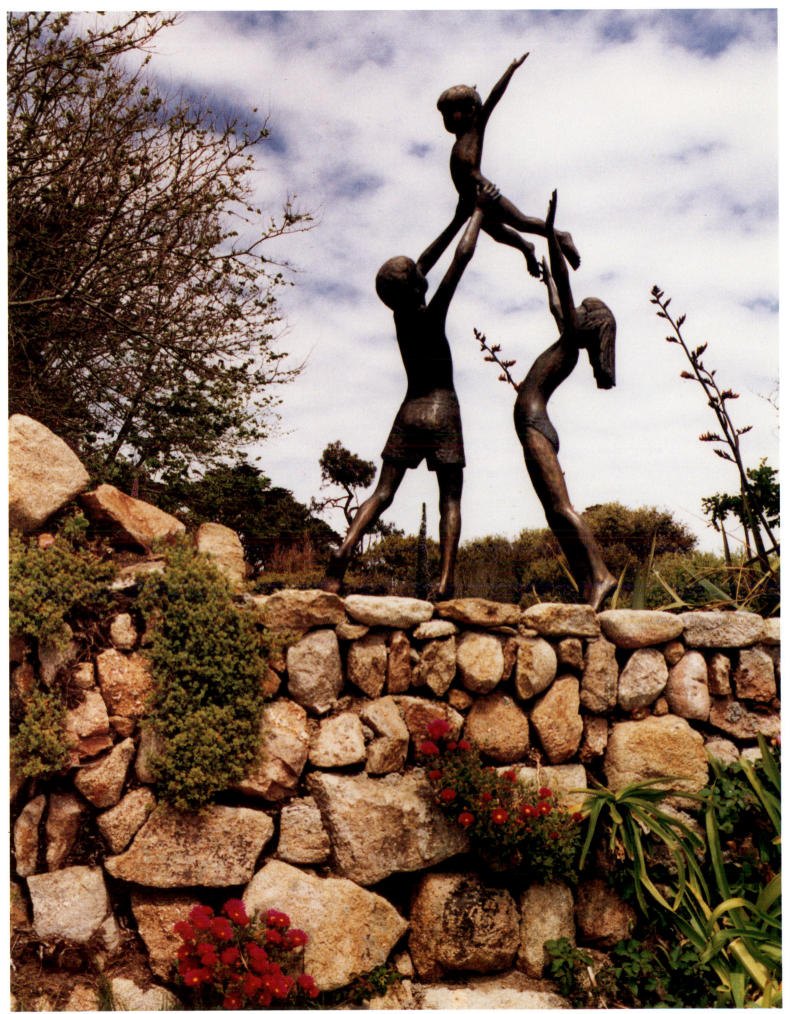

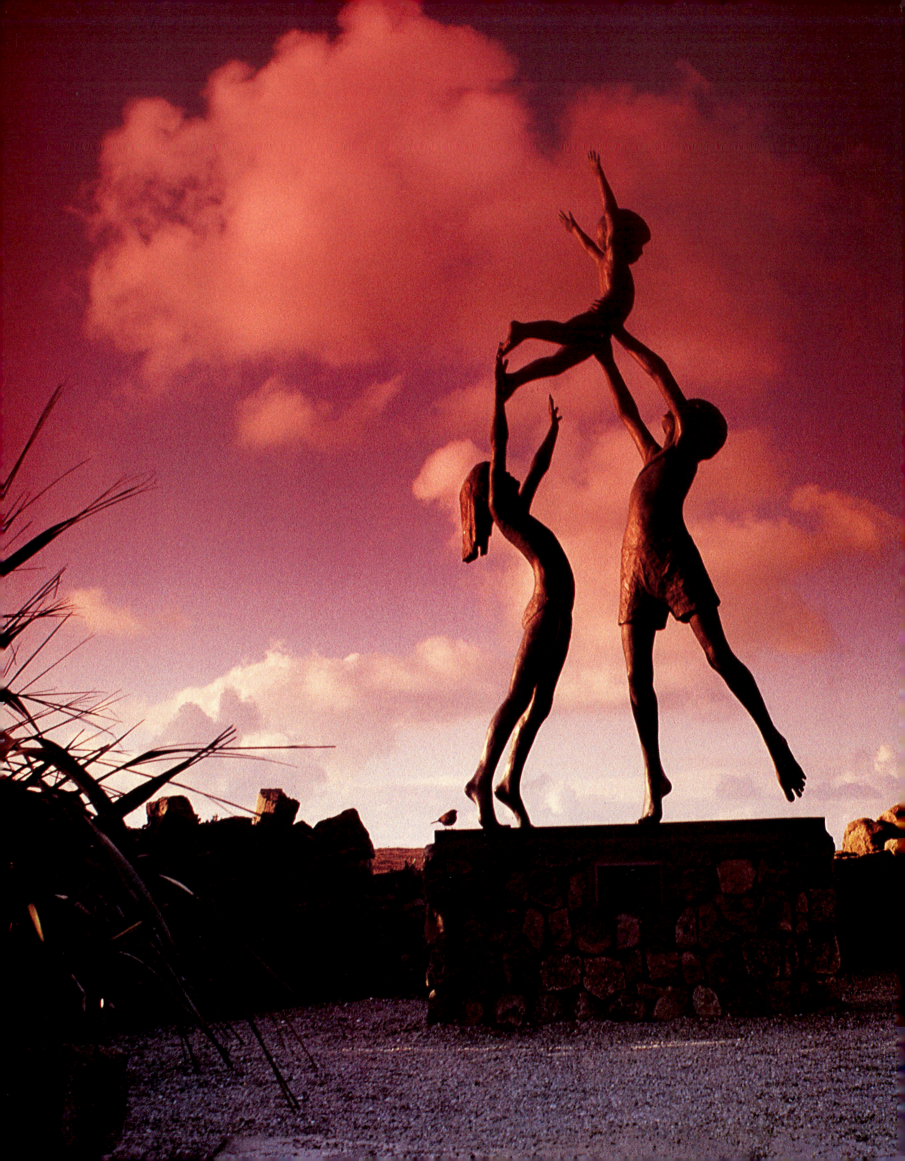

This is an attempt to express pure joy.

1990

Gaia

MULTICOLOURED SOUTH AFRICAN MARBLE, 52″

Tresco, Isles of Scilly

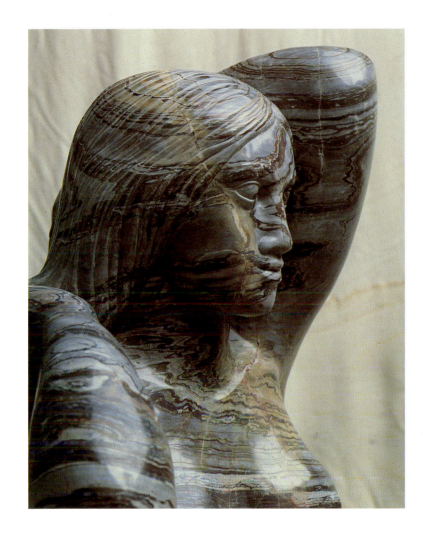

Detail of *Gaia*

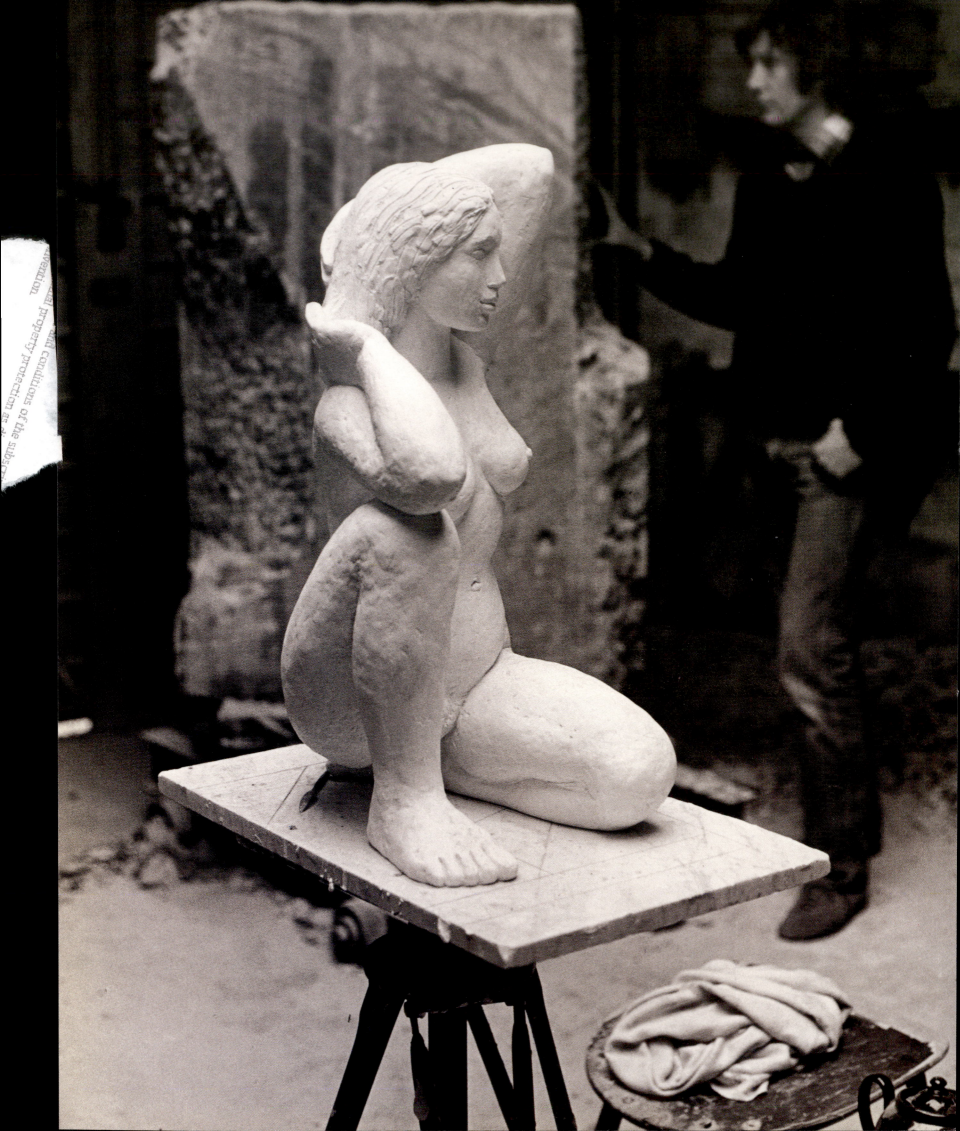

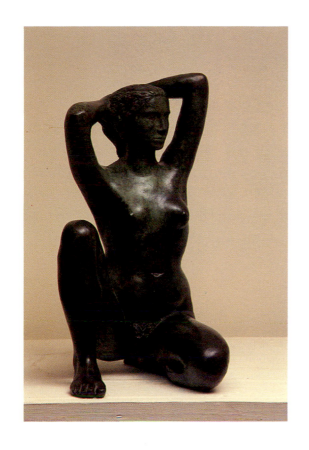

The block of marble was a present
from George Harrison, of the Beatles.
It stood in the studio for a long time before
Gilli and the sculptor decided what to make.
She posed for the figure, which was
to be a goddess of the earth.

The sculptor gazes at the half-formed block
while his son Roland slowly turns it round.

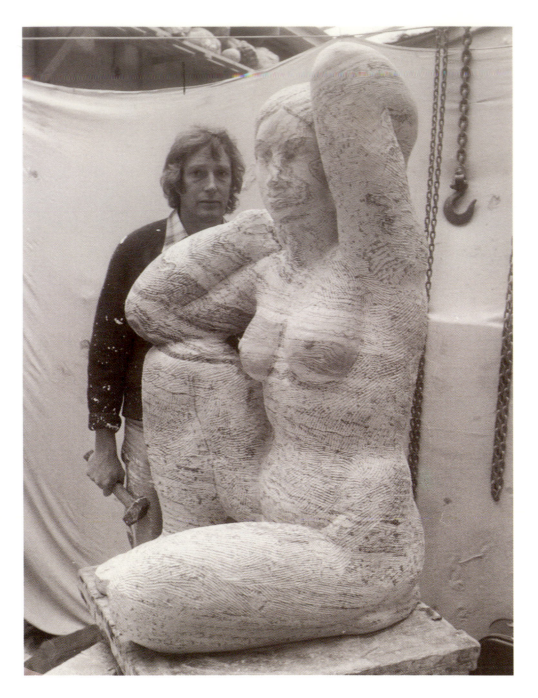

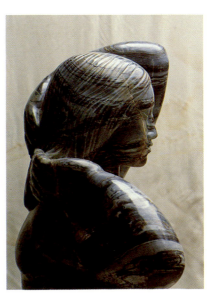

The marble's varying hardness made
it exacting to carve. The figure grew out of
the block over several years, the forms being
determined by the colours as they appeared.

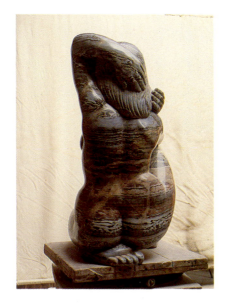

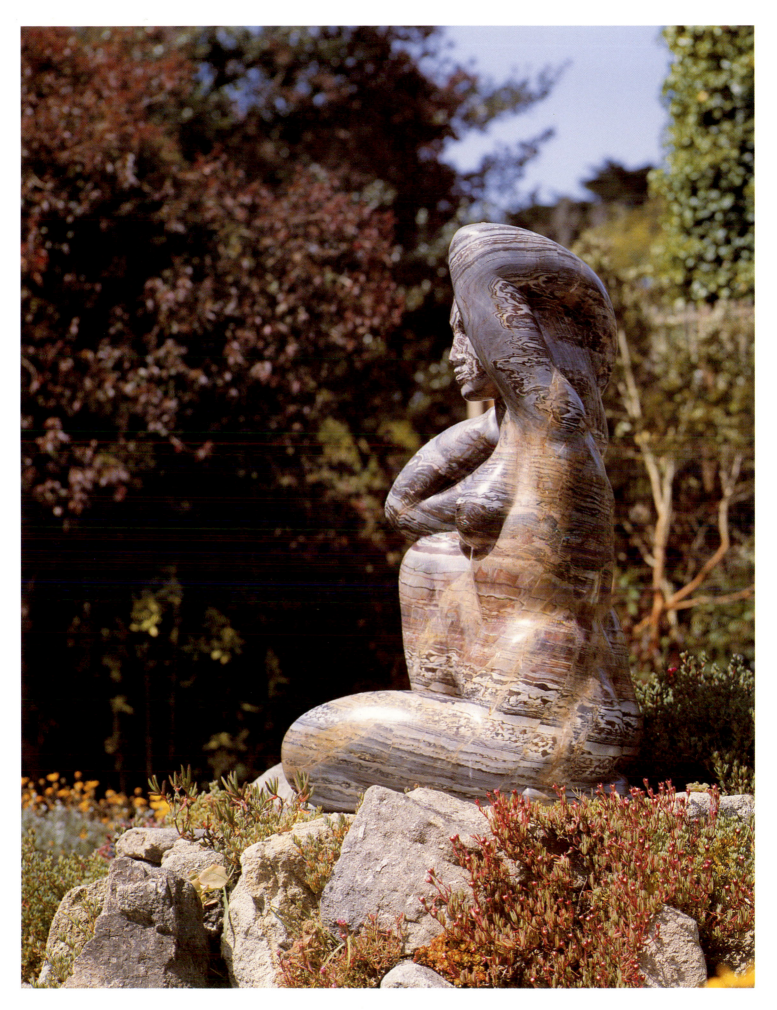

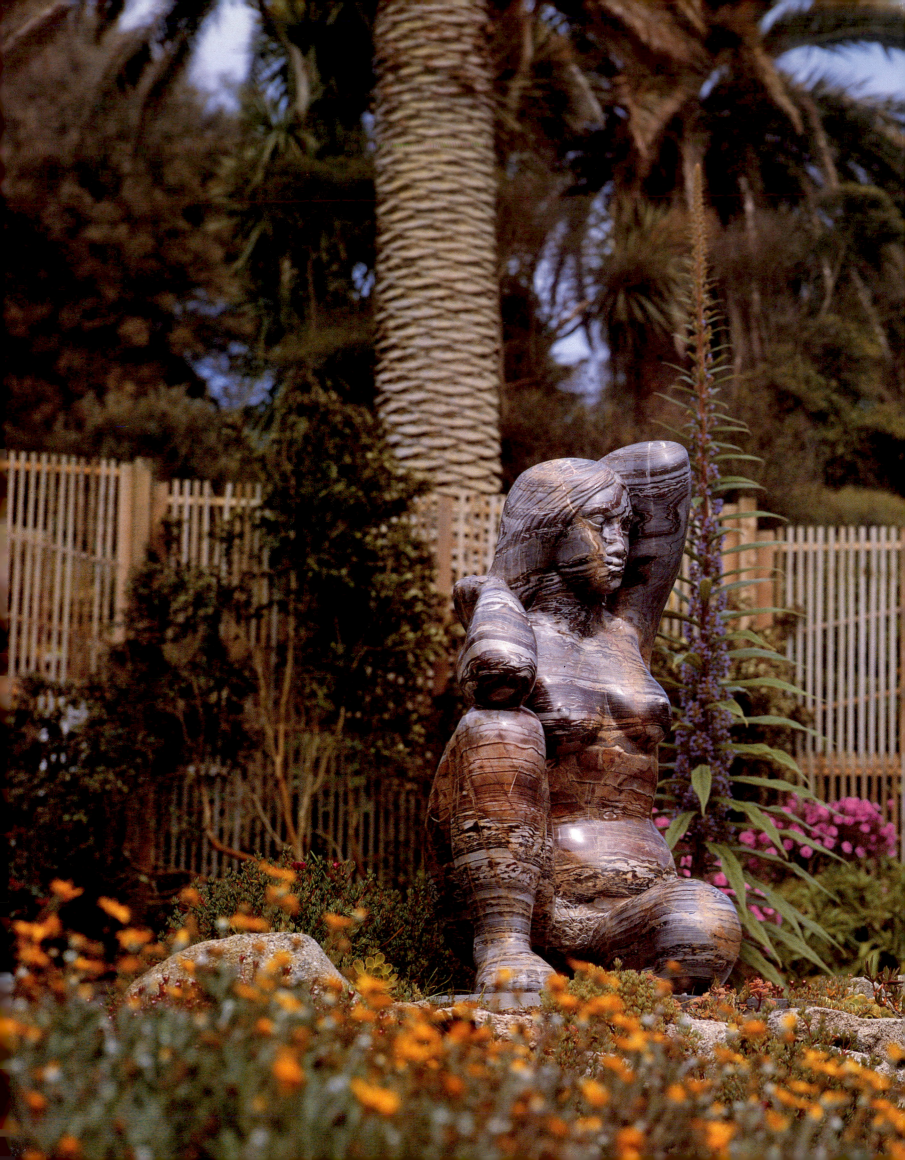

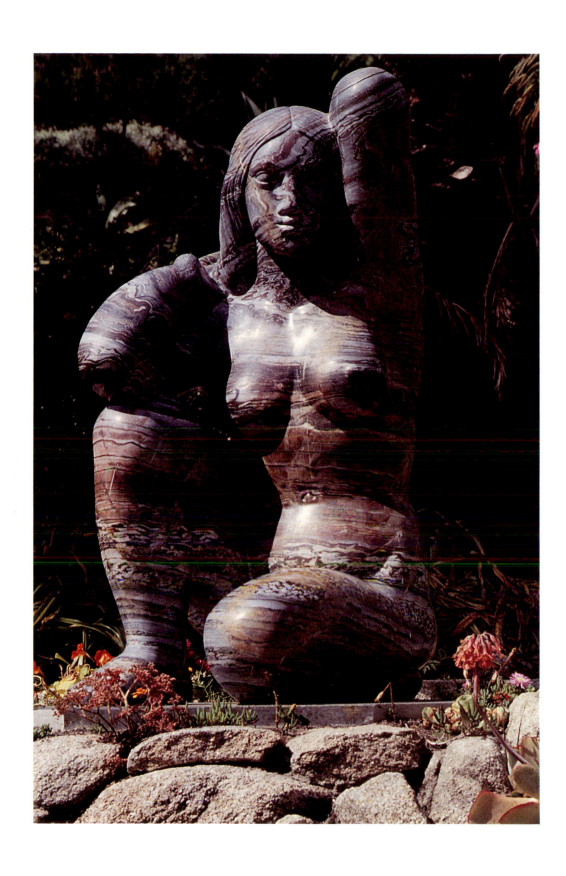

In the Abbey Gardens on the island of Tresco

she has found her perfect setting.

1991

Goddess of the Woods

ROSSO ORBICO MARBLE, 42″

Highgrove, Gloucestershire

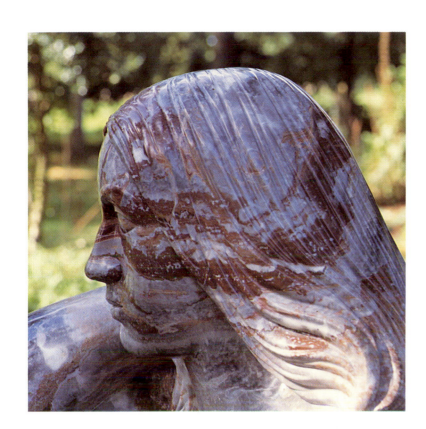

Detail of *Goddess of the Woods*

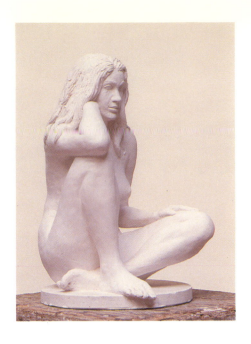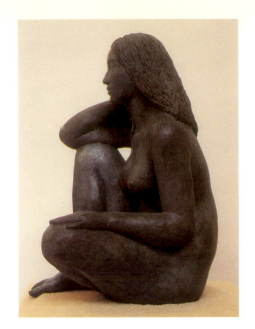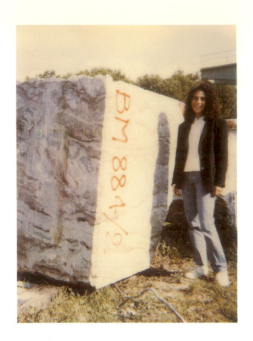

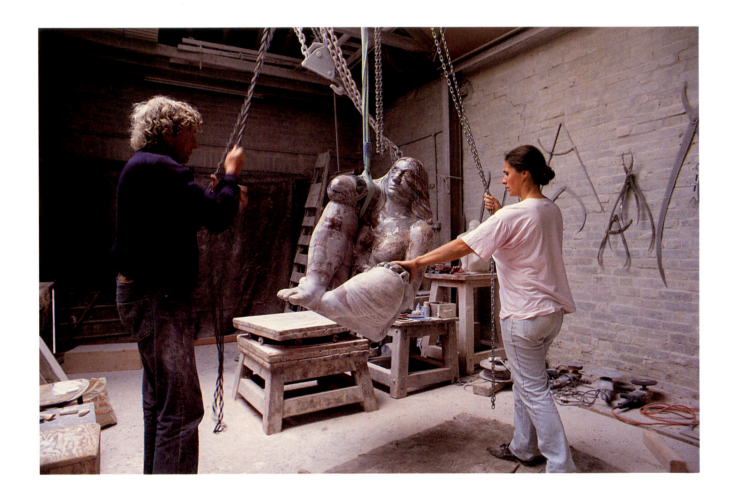

The composition became simpler as the idea matured.

Many hours of deep thought go into the creation of a
work such as this. Rodin said,
'Contemplate your work at twilight.'

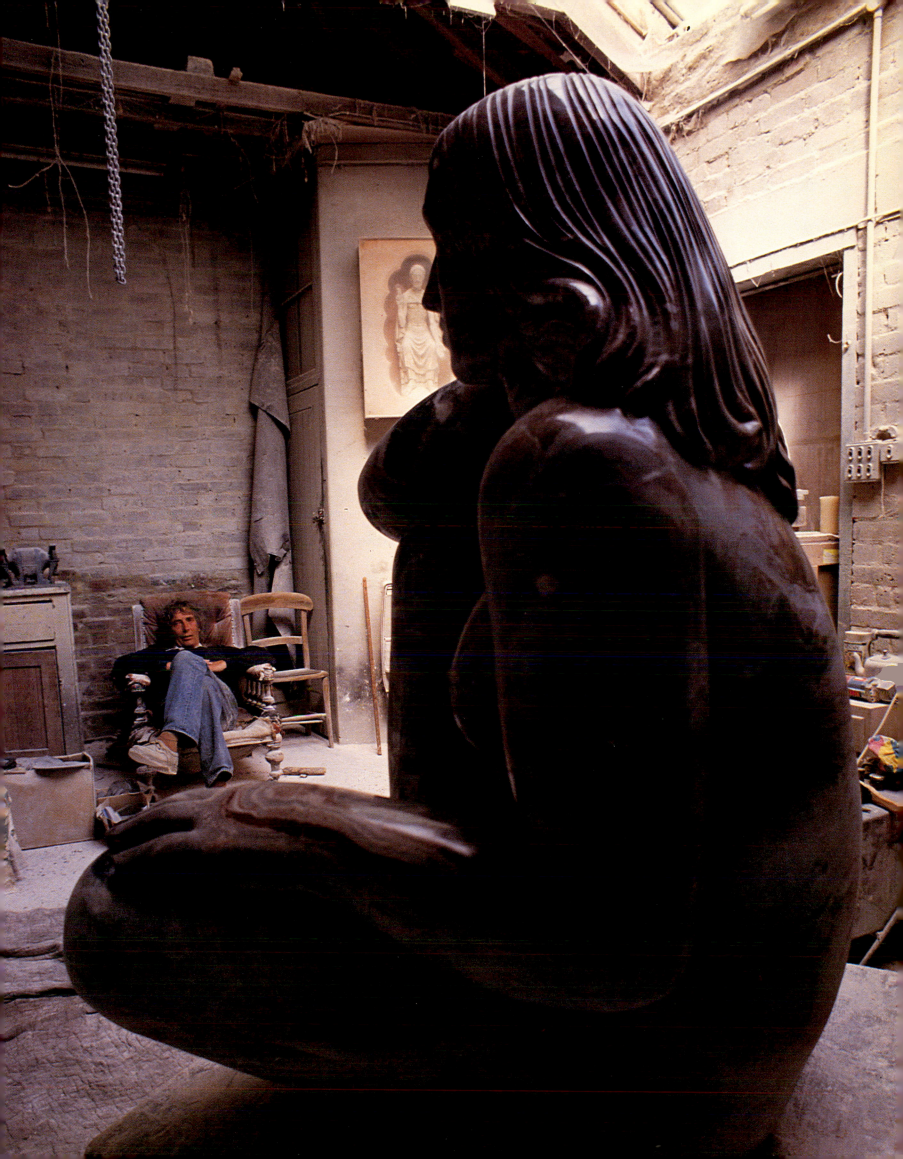

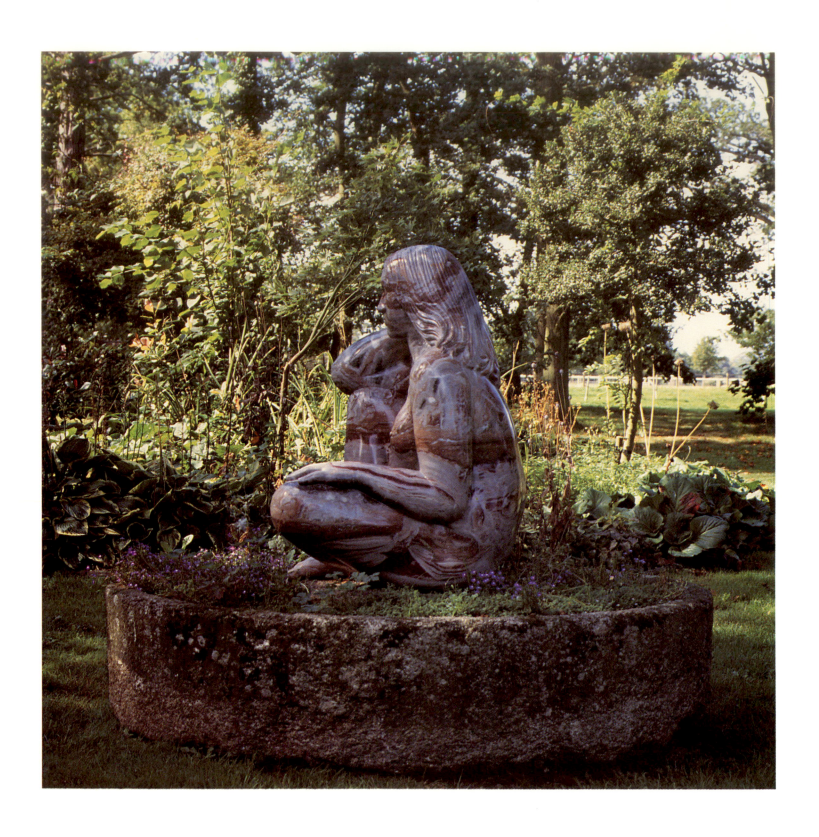

This carving was commissioned for a specific place in a
quiet woodland garden, within an oak grove. The figure was
to be similar in feeling to *Gaia* on Tresco, calm and still.

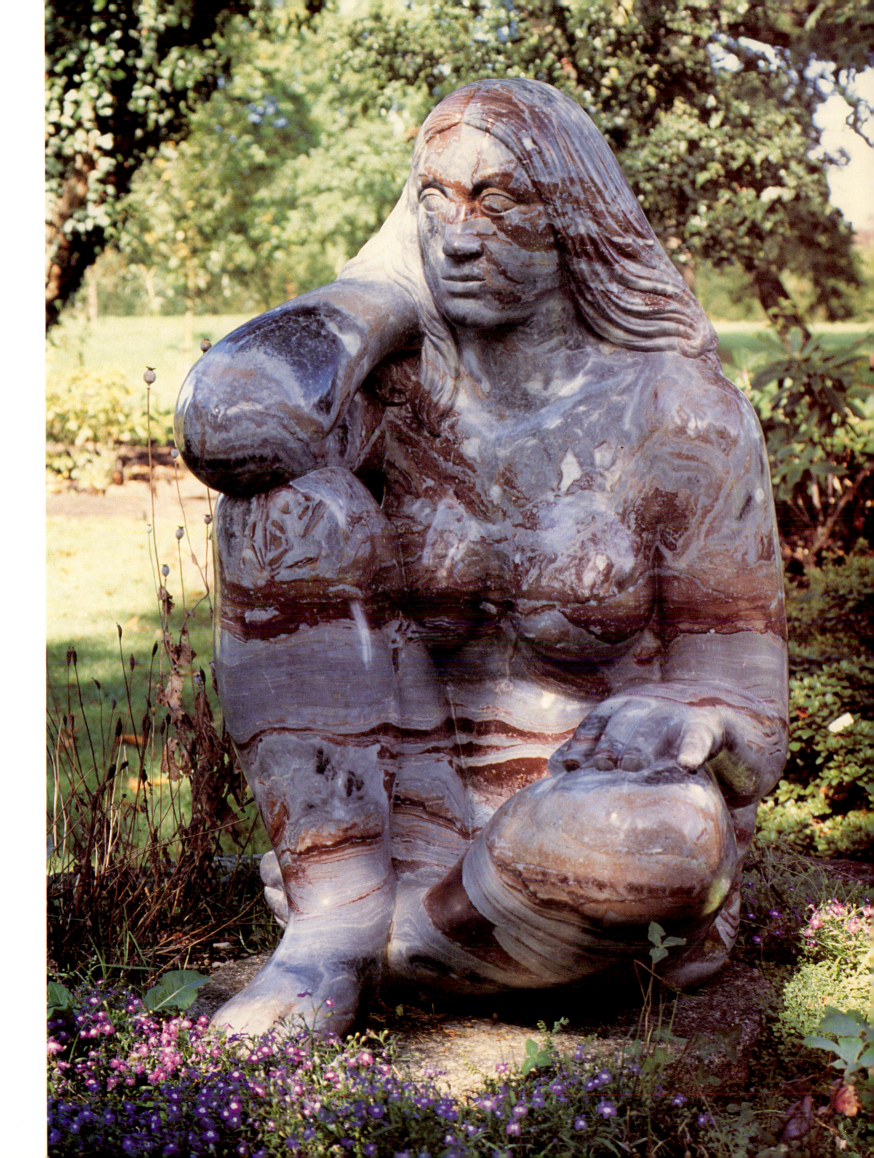

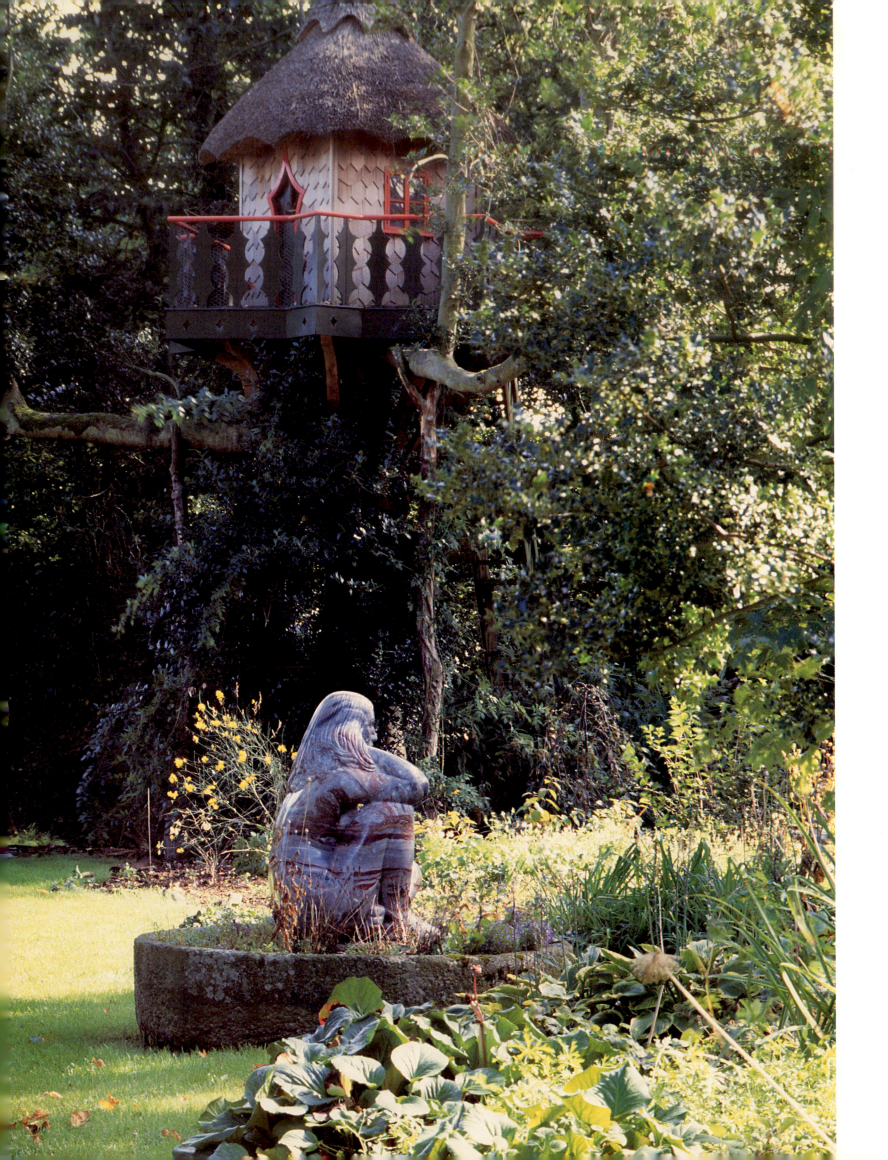

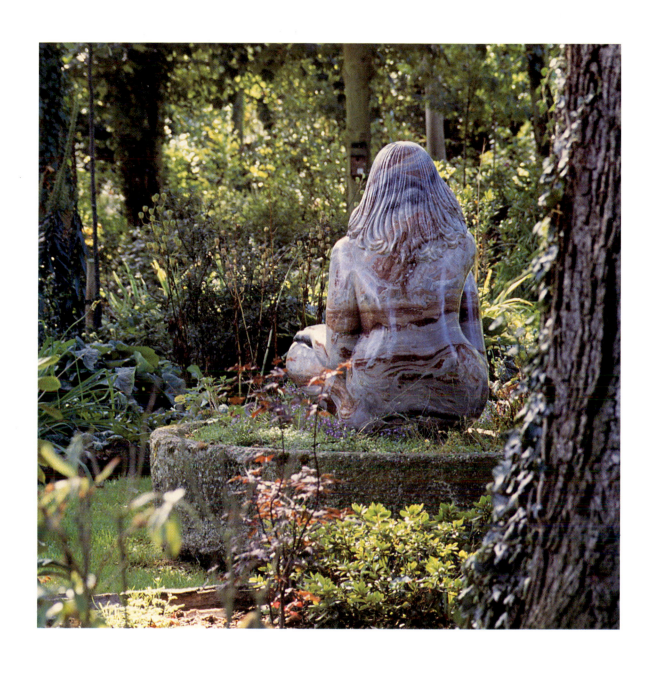

The sculptor has tried over the years
to let his carvings remain as rocks,
so that they blend and flow with
the natural world.

African Journeys

The sculptor disappears from time to time in wild parts of the world, studying animals. He either draws or models them in the bush, and brings the finished sculptures home to be cast.

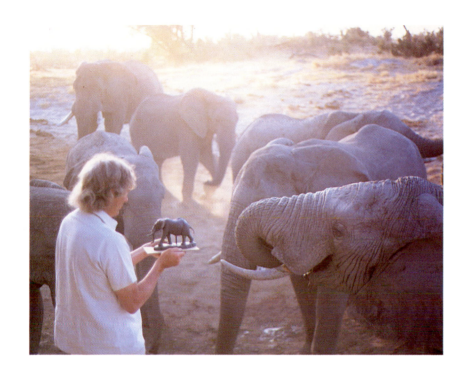

Working at a waterhole

Pages from a tiny watercolour book painted in Kenya in 1988.

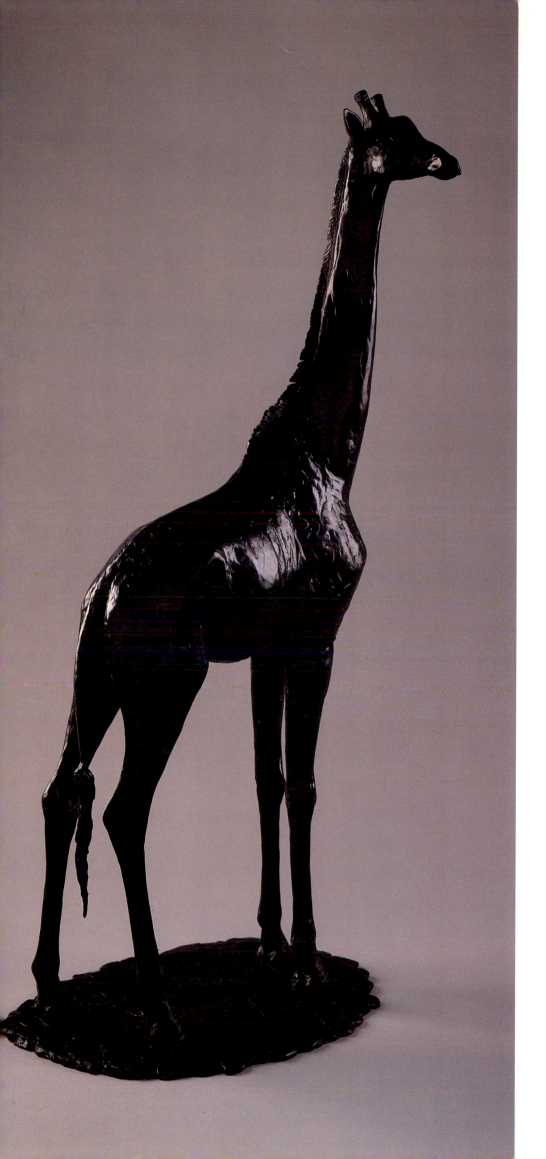

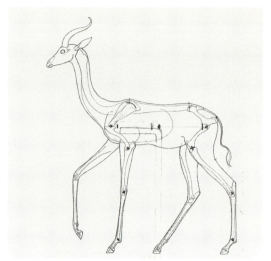

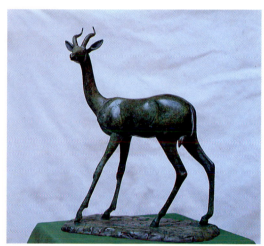

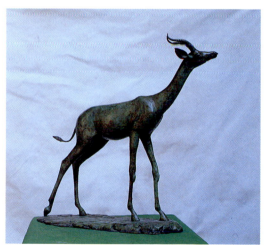

Maasai Giraffe, 1990

Studies of Gerenuk, 1989

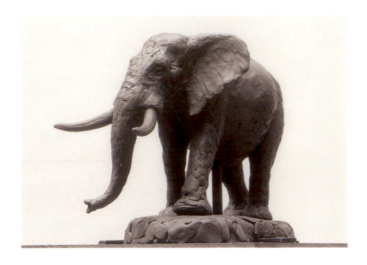

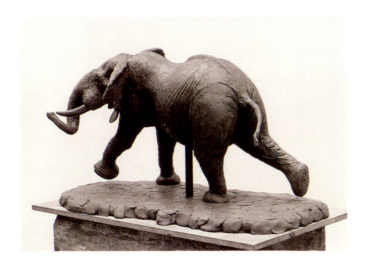

Elephant sculptures modelled at
Savuti in Botswana.

The sculptor's tent was by a waterhole
where bulls came to drink.

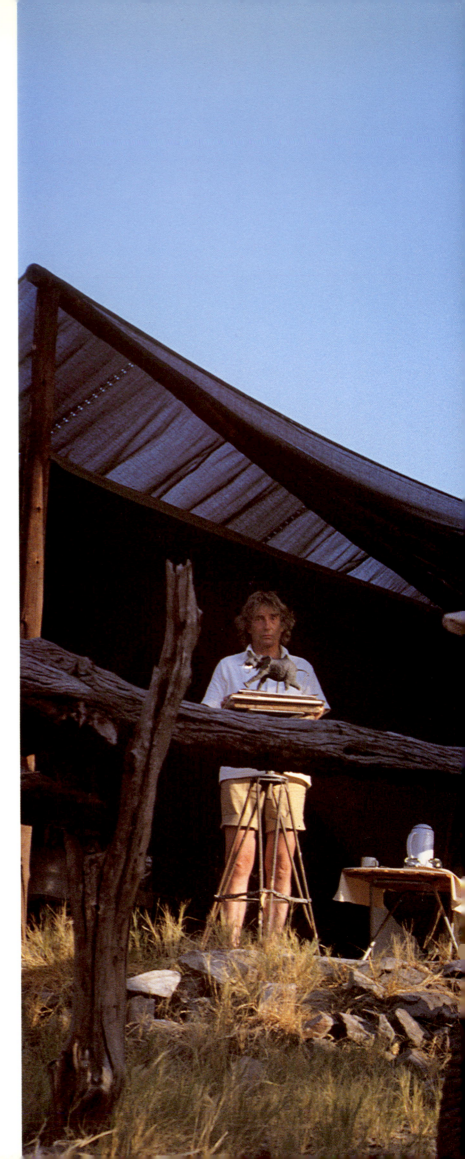

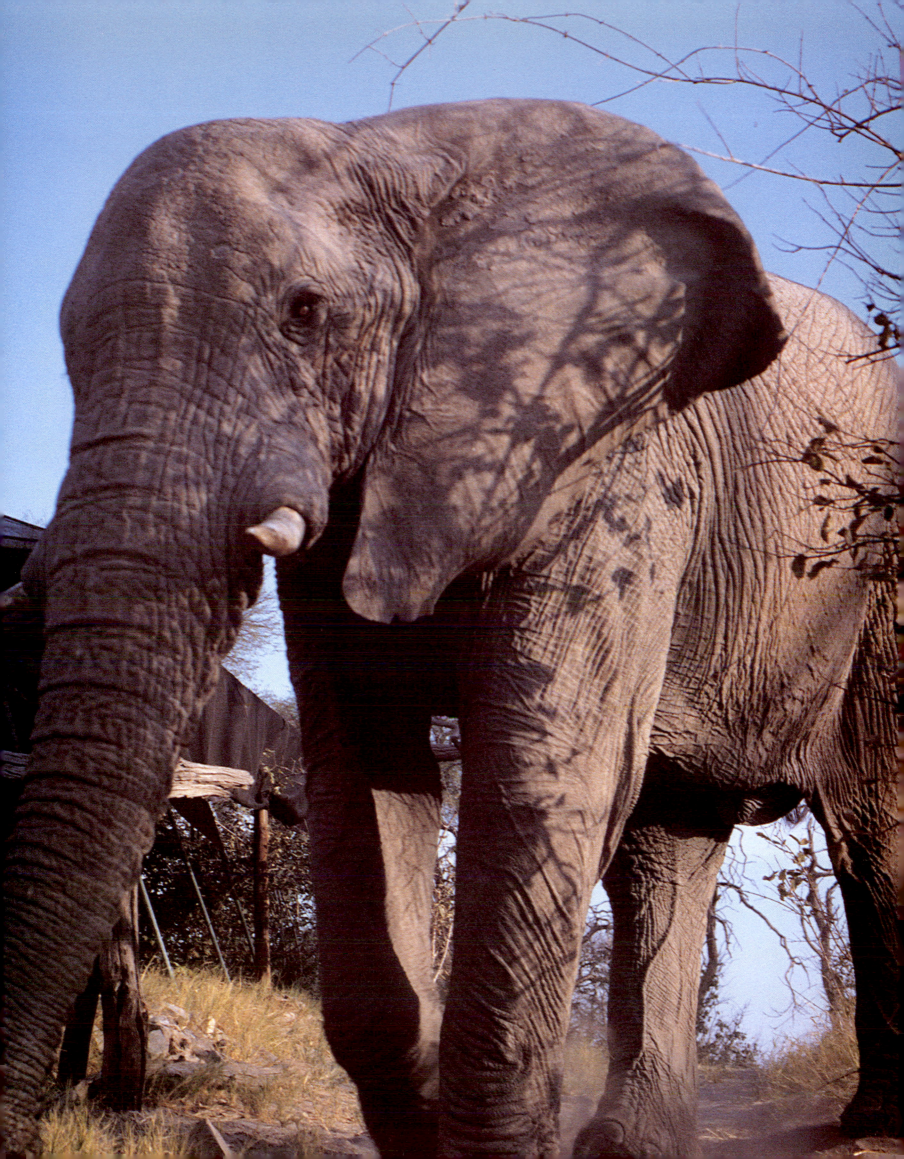

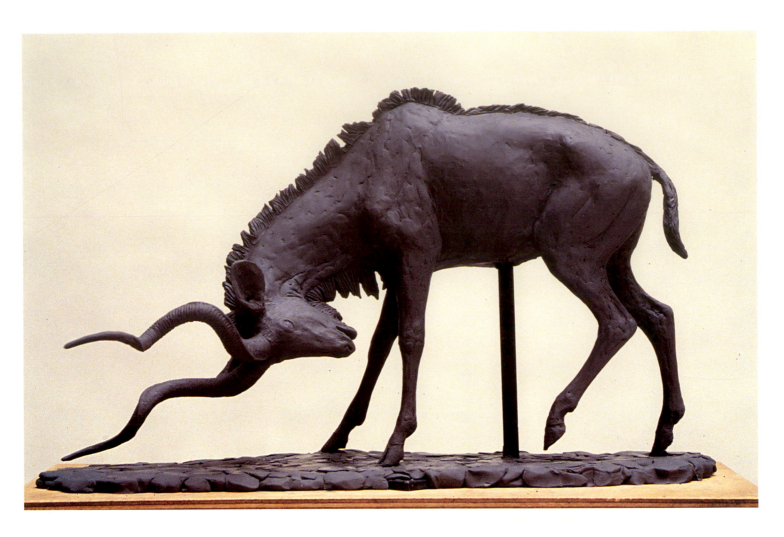

The kudu and lion were both modelled before
starting *The Queen Elizabeth Gates*.
A kudu seemed nearest in conformation to a unicorn.

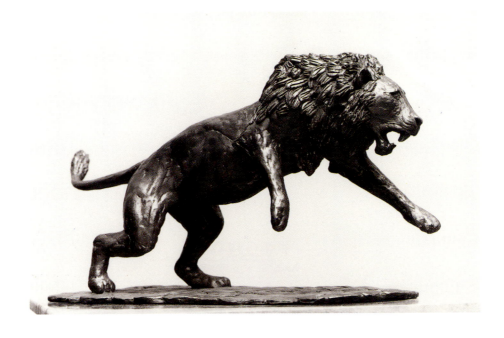

ESSAYS

Introduction
by the editor Jonathan Stone

Robert Dorrien Smith

Princess Salimah Aga Khan

Sir David Scholey

Heidi Almendinger

Marchese Gian Luca Salina Amorini Bolognini

John Hickman

Sister Mary Perpetua

Viscount Chelsea

Edward Burn

Edgar de Picciotto

Grant Simmons

Donald M. Kendall

Pamela Tudor-Craig

The Very Reverend Patrick Mitchell

David Wynne and His Patrons:
Introduction

The last book on David Wynne's sculpture, which I edited in 1975, covered only six years of his work. For a combination of reasons this new volume has not been possible until now. This has made the challenge that much greater; the variety and extent of David's work mean that a single essay on it cannot expect to reflect the joy of the creation felt by those who enable that creation to be – his patrons.

David Wynne's patrons have throughout his career played a pivotal partnership role in his creations. Sadly, Lord Taylor, the founder of Taylor Woodrow, was not well enough to contribute to this volume; it was he who commissioned the earliest public carving by David Wynne – the seventeen foot granite *Teamwork* – which, more than any of his works of the 1950's, enabled David to move up the thorny path that is the young sculptor's lot. *Teamwork* has, in its two dimensional form, been the device of the Taylor Woodrow company for almost forty years. Later Taylor Woodrow commissions followed including *Girl with a Dolphin* by Tower Bridge and *Leaping Salmon* in Florida. There have been other much-commissioning patrons such as the Earl Cadogan and his son Viscount Chelsea who have been responsible for *The Dancers*, *Dancer with a Bird*, and *Girl with the Doves* all on the Cadogan Estate. Indeed, what comes out of the contributions to this book is that David Wynne is very much a patron's sculptor, a man who rises fearlessly to every new challenge and succeeds through the application of professionalism. His fearlessness in a more physical sense is demonstrated by his adventures in the Rocky Mountains, when preparing to carve his grizzly bear for the PepsiCo Sculpture Park, and more recently by communing with the African elephants in Botswana.

Stainless steel was an appropriate metal for Sheffield's *Horse and Rider*: my suggestion that he should use this metal did not cause David to flinch despite the fact that sculptors are not normally expected to work in a metal whose melting point is three times that of bronze. Stainless steel requires oxyacetylene welding techniques the complexity of which so clearly came out in the BBC six-part television documentary 'Taking Shape', which recorded the commission from concept to unveiling.

However much David's fearlessness and professionalism are admired, it is the joy he generates which distinguishes him from others in his field. His patrons have written of the infectious enthusiasm with which he works and how he rewards them with such great satisfaction from their commissions.

But what of the public who in so many places all over the world enjoy his work? They may not know his face, or even his name, and in that sense he might almost be thought of as 'The Unknown Sculptor'; yet hundreds of thousands of pairs of eyes have looked at and formed an affectionate attachment to David Wynne's public works. For many, *Boy with a Dolphin* defines a certain area of London – 'Yes, I know Albert Bridge – it's where that marvellous sculpture is'. And what Donald Kendall of PepsiCo says in his contribution about the grizzly bear in the sculpture park he created could also be said about Guy, the black marble gorilla, at Crystal Palace Park in London and the *Pasadena Bird Fountains* in California.

As Graham Hughes said in his introduction to *The Sculpture of David Wynne: 1969–1974*, 'sculpture, like any art, speaks for itself'. David Wynne's sculpture tells me two things above all – first that, as an animal modeller, he may never have an equal. Just look at the range – from an egret in silver two inches high to the grizzly bear weighing twenty-six tons; from the range of dolphin sculptures made over a period of twenty years to the new suite of three African elephants; and from the running fallow buck to the leaping salmon. Secondly, it tells me that David is a deeply religious person who derives much of his inner creative strength from that fact. Four times has he portrayed Christ: the Black Christ at the Church of St Paul at Ashford Hill; the Christ and Mary Magdalen in Ely Cathedral; *Christ on a Donkey* in 1955, and almost thirty years later his figure for the west front of Wells Cathedral. Sister Mary Perpetua's contribution about the creation of *Saint Raphael* gives great insight into David's spirituality. This is further emphasised in the figure of his wife, Gilli, who died two years ago. He made the sculpture shortly after her death and it is a remarkable work; she was a strength to David for so many years and was his most percipient critic. I am sad not to have had her comments on this book. We hope that she would have approved of it and agreed that it was a fitting tribute to her.

Jonathan Stone
East Ilsley, December 1992

ROBERT DORRIEN SMITH
Tresco, Isles of Scilly

Since my childhood with its memories of David's visits to the island of Tresco and having seen and admired examples of his sculpture in other places, I must confess that I had always coveted the idea of commissioning a David Wynne bronze for Tresco's Abbey Garden.

The Abbey Garden is a most magical place and for many years I had a particular site in mind for a sculpture to add another dimension to the botanist's paradise although much of the formal architecture of the original 1830's garden design was buried under rare and exotic plants from all over the world. In the early 1980's the garden was a lush riot of flowers and vegetation – almost to the extent of seeming overgrown.

In January 1987 we experienced frost and snow on the island – a phenomenon unknown for a generation. The garden was devastated – huge trees and thousands of plants and shrubs were killed and the Mediterranean-style terraces were transformed into a barren wasteland. One could certainly see the architecture of the garden then – in fact, one could see very little else.

In one sense it was a disaster, but it was above all an opportunity. After 160 years of growth and development the garden had had a particular form – now we were confronted with new spaces, openings and vistas and the opportunity to replan and replant this amazing place of beauty.

It was a complete coincidence that took me to David's studio one day in January 1989. I had not seen him for years but I still harboured the desire for a Wynne bronze at Tresco and I had a number of pre-conceptions about what it might be and where it might go. Whilst walking and talking in David's studio after lunch that day, I remember asking David what large object lay hidden beneath a shroud of dustsheets. We took the sheets off to reveal a magnificent marble carving of a kneeling girl. I saw and knew instantly that she should go in the centre of the Abbey Garden. I put aside all ideas of a bronze. The power and presence of this carving captivated me totally and she instantly became the symbol in my mind for the re-awakening of the garden. I knew exactly where to put her, I could see

exactly how she would look. She would become the focus of tranquillity in the garden.

Tresco is a tiny island without motorcars so that the arrival of the marble girl was a major event which required considerable logistical planning. She is very heavy – about one and a half tons – and she arrived in a huge crate. We were faced with the problem of moving her from the tiny harbour to the chosen site in the garden, which inevitably was at the end of a series of twisting rocky paths. Every form of ancient and modern technology was called into play – large Cupressus trees were cut from the island woods to make a huge tripod; this was secured to 50 ft palm trees by blocks borrowed from fishermen; the estate engineer was in charge of making, placing and supervising the use of various levers and rollers and lifting tackle. The island stonemason had constructed a magnificent platform of granite in the circular garden and eventually, after hours of heaving and struggling, instruction and counter-instruction, theories that failed and some which didn't, she was finally settled in place.

It was decided that we should not give a name to her immediately, but wait and see and consider. It was some months before she became *Gaia*, but by then it was clear that this was not only a very great work of art but was indeed a symbol of re-birth, nature in its purest form and that she was mother of the micro-universe that surrounds her.

Such was the impact and excitement generated by *Gaia*'s arrival in the garden that it wasn't long before ideas were emerging for another totally contrasting work. There is one grand vista in particular in the garden that has always been known as the 'Lighthouse Walk'. I believe it was given this name following the placing of part of the original St Agnes lighthouse, which was one of the first in the British Isles, at the lower end of this long formal view. The site of this rather dull object had long been one of my favourites for a sculpture. I had a number of rather hazy and uncollected notions along the lines of David's *Boy with a Dolphin* on the Chelsea Embankment, but nothing fixed.

It was a very important site because not only was it the end of this great vista, but it would also become the first thing that visitors to the island would see as they emerged from the helicopter. From one side, therefore, it was seeking to be

formal, but from the Heliport side it was important to try to capture an instant feeling for the spirit of the island. Tresco is most frequently referred to by adults as a children's paradise – I have always personally taken this to mean a paradise for children of all ages. It is a place where children run free, for the most part they are on holiday, they are playing, they are having fun and above all they are happy! We even had three perfect models close at hand.

It took David's genius to translate this jumble of ideas and concepts into the *Tresco Children*. It carries all the messages we hoped it would. It is light and happy, it talks about the joy of living and the magic of the island. Thousands of people already love this sculpture; it makes them smile and conveys contentment, all in one statement.

PRINCESS SALIMAH AGA KHAN

I have been a passionate admirer of David Wynne's work since I first saw it in St Moritz in 1973. We met at a dinner and as I was expecting my third child at any moment we talked about having babies. In those days men were not encouraged as they are now to participate at births, but David had already done so, and what he said about the delivery of his first son Edward was so touching it will remain etched on my heart for ever. Later when I saw his marble carving of the newborn Edward lying on his front – reminding me of the infant Mowgli, 'the naked frog' of Kipling's *The Jungle Book* – I was struck dumb by its beauty and felt the strength of David's response to this inherently female event.

Today, in the new studio in Fulham nineteen years later, David showed me the bronze head he had made of Edward's first son, Silas Neptune, and the same thing happened. The twelve-hour-old dreaming baby, eyes closed, with all the mystery of his future life intangible and intact helps me to understand why David says at the beginning of this book 'Evil does not exist'.

David did sculptures of our young children, and of me, for my husband; and in 1981 I had the courage to commission a bronze of Shergar without Karim's knowledge. Utter discretion was necessary as the horse was still training at Michael Stoute's yard in Newmarket. Never a word escaped, and many sittings, or 'standings', later there was the beautiful bronze horse, with Walter Swinburn up, a magnificent tribute to a superb horse whose loss I will mourn for ever. My husband's delight on receiving his surprise present was a joy to behold and made all our efforts worthwhile. *Shahrastani* and *Kahyasi* were to follow in 1986 and 1988 at Karim's behest, with no subterfuge involved.

For me, David Wynne's work is a joyous celebration of creation. People or animals, famous or unknown, Sir Yehudi Menuhin, the Beatles, a child, a Derby winner, an endangered African elephant, or the staggering *Kudu* that David is working on now – all are treated with the same reverence, and translated by his sight and spirit through his hands and given to us. A gift of rare and utter beauty, truth and depth.

SIR DAVID SCHOLEY
Merchant Banker

My brother-in-law Steve Colhoun, who died in 1991, should really have written this piece. Steve was the one who *really* knew David and his work. Steve too was an artist – with a camera – and he no doubt empathised with David in ways he could not fairly express and I could not fully appreciate. I do know, however, that Steve shared and admired David's fascination with and command of the technicalities of his craft. Steve was one of David's best friends and most prolific collectors.

As a result, David and his work have always been one of our family's favourite subjects of conversation. His pieces were always around us, in Steve's home in Connecticut, and in my wife, Sandy's, and mine in Hampstead; because David and his sculptures always generate interesting stories and evoke vivid memories.

It would of course be presumptuous and unfair for me, an amateur in the true sense, to attempt an assessment of David's work – so I will not. I do know, however, that when it is assessed it will be a rewarding challenge because of the variety in the strands and drives of personality and character which go to create his pieces.

I will dwell only on a very few obvious and personal impressions which I have gleaned over the forty years and more since we first met.

The spirit which pervades and permeates his approach to every project is Celebration. This admixture of enthusiasm and joy and love and energy is one of the most fresh and refreshing auras in my experience. It is enlivened by a central disingenuousness which, whilst clothed in the garb and couched in the expression of mid-twentieth century bourgeois conventionality – public school, ancient university, armed service commission, elite pastimes and gentlemen's clubs – nevertheless preserves and projects an innocence and idiosyncrasy which are transmitted through and reflected in almost all of his work.

The physical side of this Celebration is obvious but nonetheless delightful and gratifying: female nudes, lying, sitting, studying, sorrowing, sleeping,

flying – sensuous but never sensual; powerful, graceful males; penetrating, affectionate portraits; unsentimental animals. The spiritual dimension is the more powerful for its lack of apparency. The spiritual stability of his pieces, symbolic or human, conveys a conviction which has emerged not without inner turbulence and stress over his life, anchored by his Gilli whose mother-earthiness and mother-courage are mystically combined and projected with her wife, lover and materfamilias essence in David's memorial homage.

The care and thoroughness with which David plans and prepares a project are in contrast to the speed and instinct with which he moulds clay and chisels stone. Steve's understanding and appreciation of his work was neither effusive nor uncritical; it was rooted in respect for the artist's integrity and independence – honouring the freedom of expression which made analysis inappropriate and even intrusive.

David lost the company of Gilli and of Steve in the same year; before and after each death, he produced some of his strongest and most touching work so far. That's what I mean about Celebration.

I asked Julie, Steve's daughter and David's friend, what she felt about David. She wrote:

> Clothed in natural unstudied grace,
> Rosie gazes on musings unknown;
> She forgets herself, her immediate place –
> the stool where she sits is solitude's throne.
>
> Suspended amid their rising flight,
> the doves take wing, lifting the girl
> in her own release; the Dancers might
> return a man to their passionate whirl.
>
> Two lovers embrace the warmth of one core;
> probably blood does course through stone,
> gathering all that went before
> in arteries feeding the embryo.
>
> A vibrant spring gives life to the bronze;
> A heartbeat embodies the soul's response.

We have many of David's sculptures but have yet to commission him. If I do it will be for two figures; Hermes, the most varied and mystical of the classical deities, and a self-portrait – or maybe that could be just one.

HEIDI ALMENDINGER
Resident of Botswana

The African sun stands at its zenith, there is stillness in Savuti, the air is clean, the land dry and the colour of sand. The ground is too hot for the human foot but the slowly passing elephants have adapted over eons to the harsh conditions of the continent. Quietly they follow their track to the waterhole and have recently become accustomed to see a grey-haired man outside his khaki tent. Sometimes they stop in silence to watch him, sometimes they flap their large ears and wave their trunks, sometimes they just pass quietly by. Do they feel how this man is fascinated by the myth that surrounds them? Do they value the concern, love and admiration he feels for them? Their dignity and deep wisdom have touched David's heart. He wants to pay tribute.

After a first visit of two short days he has now returned with his tools. Daily for three weeks this spare, tall, figure stands bending over his tripod making elephant sculptures. It is so hard at first modelling the plasticine over the naked armatures but soon it takes shape and the artist is lost, oblivious to the heat of the day: he is creating. 'I must do them justice: they must be alive'. He stands back, lights a cigar, gazes long and carefully, unhurriedly picks up the spatula again, takes off plasticine or adds it, moves a leg, alters the tail, bends and rebends the trunk. He asks for criticism from his new-found friends who share the deep love and understanding of these mighty creatures, and there are lengthy discussions whether or not the trunk is correct or the circumference of the feet are in proportion, or the skull is heavy enough.

David is delighted when the Department of Wildlife invite him to skin the skull of a dead bull. With sketch pad, pencil, and measuring tape he goes to study the colossal cranium of the bull. He returns with new enthusiasm and again reshapes the head. He works quietly dedicated, completely absorbed; he has entered the world of elephants. He has given birth to two bulls, both beautiful, each in a different but typical pose. What a gift this man has, and so much feeling for our elephants.

The last elephant will be charging, a difficult movement to capture. David disappears for a day and when we see him again, he has found new

energy and inspiration. The bull stands there in a rough state for us to see; we are in awe. Such are the proportions and the movement, it is as if David's elephant wants to charge us. Again he wants our comments and as so often we find ourselves having to look first at the live models. We are now being trained to study small parts which we have carelessly overlooked. We learn to see with David's eyes not just the obvious, but the details which make the elephant a perfect entity, God's creation.

The days pass and the sculpture gets its wrinkles, its toenails, the trunk is moved closer to the tusk, the lifted feet get pads and the tail is swung up just right, the ears are perfect and need no alterations. David never tires of watching the elephants at the waterhole and always finds new details. He is meticulous. 'So many broken tusks, let me give the charging bull a broken one too'.

Here, then, they stand before us, three master-pieces in the soft evening sunlight. Soon the sky is turning pink and the sculptures become silhouettes.

We must bid farewell to the sculptures and to the man we have grown to love and who has grown to love us. David belongs here; he understands Africa, it has touched his soul and no doubt he will be back.

MARCHESE GIAN LUCA SALINA AMORINI BOLOGNINI
Banker

I have always been attracted to sculpture, be it in stone, bronze or clay. Sculpture has a tactile sense as well as a visual one; and it is perhaps in the Cairo Museum that this can best be appreciated, as the statues there can not only be admired, but touched.

In order to commemorate the restoration of our family house in Bologna, David suggested a sculpture of my wife and myself. Obviously, he said, this group would have to be naked. After some hesitation we both agreed. Posing was an extra-ordinary experience. I learned the secrets of the creation of the human body, its complexity, the immense care taken in measuring, the sheer physical effort of producing from virtually nothing the spines and then the bodies themselves. In the end what matters is the harmony between the two bodies, the group, and the emotion that transpires. Then the movement. David, like Gianbologna, whom we often discussed at length, infuses move-ment into the sculpture, movement that emerged from the classical beauty of its form.

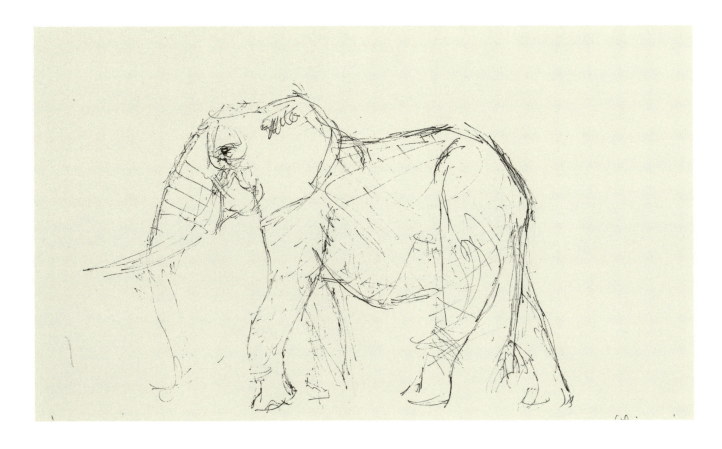

JOHN HICKMAN
Property Developer

I first met David after he telephoned me in response to a letter I wrote trying to track him down.

'You must come to my studio', he said.

'Right', I replied 'I will be there in ten minutes!'

I had recently seen a documentary series on television – 'Taking Shape' – about a sculptor who had done a major piece for the centre of Sheffield and I was so impressed that I made a note of his name. As a property developer, I happened to be in the Planning Office of the Royal Borough of Kingston-upon-Thames three weeks later, discussing a project. 'Have you ever considered commissioning a sculpture to stand in front of one of your buildings?' the planning officer asked.

'No, but I would certainly consider it. Have you anything in particular in mind', I asked.

'What about the three salmon of Kingston? They have formed part of our Coat of Arms since 1572'.

'Wonderful!' I exclaimed. 'I promise to do it, and David Wynne will be the sculptor'. Thus started a warm and amusing friendship and the first of several sculptures I happily commissioned from him.

David is keen that his patrons inspect progress from time to time. In the case of *Leaping Salmon*, he invited me to examine the six foot plaster, after I had agreed the design in an eight inch maquette. Once finished I was allowed to comment, but not before! Then came the visit to the foundry, and finally *Leaping Salmon* was installed. David invited Lord Home of the Hirsel to unveil it. At the moment the veil was pulled away, the fountains sprang to life.

Subsequently I commissioned *Fallow Buck*, *Sealion Family* and *Two Dolphins*. As one who has greatly appreciated David Wynne's work for many years I find I compare all other sculpture with his, and rejoice in the fact that although some are more magnificent, most are inferior. His work has aroused within me an appreciation of an art form which has taken me to Greece, to Italy, to Egypt.

As a developer I have the opportunity to commission sculptures from time to time, not only to enhance the related building but also for the enjoyment of the passer by. David Wynne has contributed enormously in both these aims.

SISTER MARY PERPETUA
Principal of St Raphael Hospice's, Cheam

The fascination of David Wynne's sculptures lies partly in their powerful expressions – from the vitality, freedom, grace and beauty of the *Boy with a Dolphin* to the joy, confidence, serenity and assurance of *Saint Raphael*.

I was overjoyed when friends offered to commission a sculpture of the angel of healing to complete the courtyard of the new Hospice in the grounds of St Anthony's Hospital in Cheam. The concept of the hospice was to minister to all the needs of the terminally ill and what greater need than that of protector and guide through the dark portals of death? David Wynne accepted the commission because, as he said, 'I had been seriously ill – the invitation came as I was recovering and I felt a sculpture of the angel of healing was a fitting return to my work'.

It would need an expert to define the precise elements of this perfect example of David's work. I can only express my admiration for the beauty of the form and the clarity of its message. David and I discussed our vision of the finished work. We did not want it to excite the patients as a work of art or to puzzle or to worry them. We were not after a 'clever piece' which was difficult to understand. There had to be immediate recognition of a simple and direct message.

A study of the sculpture shows how successfully

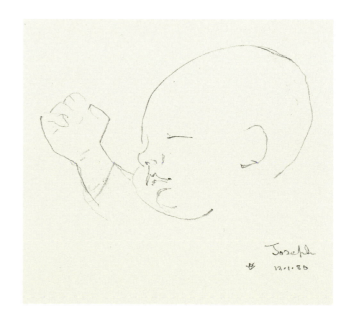

that shared vision was implemented. It can be seen from every angle and the message is crystal clear: 'Do not be afraid – I will guide you for I know the way well.'

David claims, and he ought to know, that the actual posture of the angel which is the essence of its success was the inspiration of his wife Gilli. When she saw the courtyard into which it was to be placed and the windows of the surrounding rooms, especially those of the small but beautiful chapel, she suggested that the figure should make a one hundred and eighty degree turn so that from whatever angle it was viewed, the message of hope and re-assurance would be plainly visible.

What else can one say? When one sees a prayer in bronze it is difficult not to absorb its beauty and respond to its message in silence. The face expresses a tenderness of love that surely mirrors the loving kindness of our heavenly Father in whose presence the angel stands. The hands seem to express a yearning not only to be there in His heavenly home but to encourage those soon to enter eternity to entrust themselves to St Raphael's sure guidance.

The feet express the same eagerness to be gone on a journey that has so wonderful a goal. There is such strength in the wings that they recall the words of the psalm, 'In the shadow of your wings I take refuge.' for there could be no faltering when upheld by such tenderness and strength.

Though angelic, the figure is not turned fully towards heaven. This was precisely the intuition for which we and David are indebted to Gilli.

The face of the messenger is turned to weak, suffering humanity and the whole figure, while poised for flight, is patient as it waits for the approach of the one needing guidance and assistance. This is offered, not imposed, and hence the peaceful calm in the whole stance. Anxiety, stress, rush are all alien to this figure for he knows the God of Peace is waiting at the door of eternity.

When we chose the name St Raphael's for our new hospice we did not know it was to be the setting for such a striking expression of the philosophy of the hospice movement. David assured us that the sculpture of St Raphael is 'a small piece of my work and it was made with love'. Indeed it expressed love; and its incredible beauty is proof that love lasts for ever.

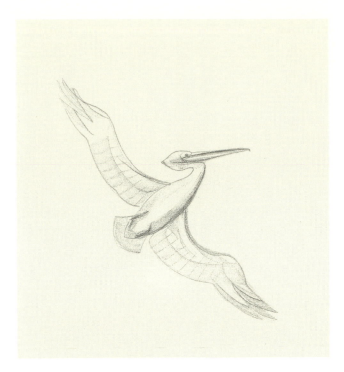

VISCOUNT CHELSEA

Our family relationships with David Wynne go back to the early 1950's and to his days as a young artist in a small studio room in Notting Hill Gate. The first work actually commissioned is that of a head of me in 1953, the sitting for which was completed at Snaigow, the family home in Scotland, during school summer holidays and which now acts as my hat-stand in the office. During this time David in his eloquent and enthusiastic manner persuaded my father to lend him sufficient money to buy the ticine required for a full-sized model of his *Christ on a Donkey*, which I subsequently bought and which is now in my garden at Marndill near Wantage, and also to give the party after his first major exhibition at the Leicester Galleries in 1955.

The very close friendships established in those years continue happily and we have followed David and his work with considerable interest. There are today three major Wynne bronzes in the Gardens in Cadogan Place and Cadogan Square, the most obvious of which is *The Dancers* outside the Hyatt Carlton Tower Hotel, commissioned especially by the Estate in 1971. Equally my father, my sister Daphne, and I all have many other examples of his work in our private houses and we treasure them greatly for the pleasure and inspiration they have brought us.

EDWARD BURN
Professor of Law

As the clock struck twelve noon, David Wynne drove his car into Tom Quad at Christ Church. Twelve noon was the invitation time, and we approved of each other's punctuality. On this happy note we went to see some of the House's treasures, including the heads by David of Lord Salisbury, Lord Home and Lord Hailsham. As we walked back to his car after lunch in the Senior Common Room David turned to me and said, 'I want to sculpt you. I very much hope you can come to my house next Tuesday at 9 am.'

I had been amazed when I learned that my old pupils wanted to mark my retirement by a bronze head for the Law Library, and I was now delighted that David had accepted their invitation.

On that following Tuesday began a friendship which I treasure. I arrived by 9 am at David's house overlooking Wimbledon Common. I rang the bell; the dog barked; and David opened the door. We made mugs of tea in the kitchen and I was led to the studio with its varied examples of David's genius. In the centre was a chair on a dais, looking rather like the chair for Mastermind candidates. I sat in it and wondered apprehensively what was going to happen. David made it so easy for both of us. We talked of this and that, and of him and her, and of words and the delights of Dr Johnson's Dictionary and Robert Graves's poetry. We compiled a First XI of English poets, with easy unanimity on the first nine. I was struck by David's insatiable curiosity and enthusiasm for everything in which he was interested: before he sculpted a dolphin or a racehorse, he swam with the one and rode the other. Meanwhile David was measuring my skull and recording the anatomical details on paper. I found the whole process strange and somewhat un-nerving, delicately though it was done. As time passed, David started on the clay likeness, and I watched a work of outstanding craftsmanship develop into a perceptive work of art. It was the creation of genius, and if I had to give it an Oxford academic mark, it would be alpha plus. I have never given such a mark on a law paper. Readers of this tribute to David, please look carefully at the head. *Pace* Lucretius, *Ex nihilo totum fit.*

David was not, however, the only creator of the head. I met Gilli, their family of three generations and a pupil sculptor who worked in marble, all living in the large Georgian house. It was Gilli who was his best critic. He would ask her to come in and see how the head was getting on. She came in, gave a quick look and a gentle laconic reply. 'Make him smile. He does, you know. And the forehead is too high'. David thought for a moment. 'Yes, I see. You are quite right'. To avoid embarrassment to me, I was sent out of the studio while he used a sort of wire cheese cutter, severed the forehead laterally, removed a slice of it and then joined up the remainder. Gilli was a very dear person and I got to know her well. We shared a love of gardens and, as I walked round her's with her, I came to realise what a superb partnership they were. I dined with them both just before her tragic death. David is a family man, and of all his recent works he was, I think, proudest of a small head of his one-week-old grandson Silas Neptune.

I shall remember David's studio, with its para-phernalia, its dolphins, heads, dancers, giraffes, family treasures and yet more dolphins; his love of family; the acclaim with which his head of me was greeted by my old pupils at dinner in a full Christ Church Hall; and above all else David.

EDGAR DE PICCIOTTO
Banker

In 1985, the façade designed for our bank by the Italian architect Francesco Gnecchi Ruscone was unveiled. People could then become aware of the significance of the building that we were in the process of creating at the foot of the busy Geneva street, Le Boulevard Helvétique.

On Place Camoletti, facing the Boulevard, our building required a work of art which would enhance a completely remodelled square. It was easy to convince Claude Ketterer, the then Mayor of Geneva, of this. His strong inclination for modern art was well-known, as he had already widely contributed to the embellishment of streets, squares and parks in the city with contemporary or classical sculptures, sometimes audacious, but always perfectly integrated with the surrounding architectural environment.

We met David Wynne and our meeting with him sparked it all. We had already been seduced by his sculptures, and we understood each other immediately. Thinking of the unity of our world, of the interdependence of all the elements of our universe, of the current means of communication which instantly change our globe, David started looking for an expression of the creation of this brand new world.

When he came back to us he proposed the theme 'The Awakening Earth', which refers not only to this new state of the planet, but also to the spring of new hope. A human shape emerges from the sphere and shows that mankind always draws strength from itself. Ultimately, hope rises from the spontaneous generation of energy and from a state of permanent awakedness.

For David Wynne the selection of his raw material is vitally important, as he shapes that material to give it expression. Carved in marble, *The Awakening Earth* manifests a particular gravity, which conveys an earthly nature, thus evoking the deep origins of those new forces sought by man, which witness the birth of hope for all mankind.

The relationship between the original conception, the shape and the material was thus achieved, becoming a true expression of David Wynne's remarkable talent.

GRANT SIMMONS
Industrialist and Art Collector

A photograph of a piece of sculpture reduces its essentials to two dimensions, yet words are cruder still. Only by living with a sculpture can one fully extend one's understanding beyond the reach of photographs or words.

The impetus for even attempting these crude words comes first from the privilege I have enjoyed for some two decades of having in our home a number of David Wynne sculptures, now totalling twenty-one, and secondly because David has become a great friend.

David Wynne would have been far more celebrated in any century but this. At about the time of his birth the high priests of chill 'abstract' seized the citadels of the art world, the schools of art, the art media, and a big part of the art market. This priesthood sneers at 'mere' representation, idolising only the abstract. David's work celebrates life. Hence it will be more and more treasured in years ahead, long after the vogue of the twentieth century has passed.

To enjoy fully a piece of David's sculpture requires an appreciation of its *balance*; its *honesty*; its *life energy*; and its *love*.

In creating a piece of cast sculpture the armature is to the clay as the bones of the body are to its flesh. It is impossible to exaggerate the care that David devotes to every armature; every point is meticulously measured and assessed. David has a special genius for making every piece delicate and at the same time sturdy; the relationship between its actual mechanical centre of gravity and the core of the work ensures that every one has marvellous *balance*.

One could write a book about the lengths to which David goes to immerse himself in the living mode, manners, and all characteristics of each subject. He has spent hours in the water with dolphins, weeks in the wilderness domain of the grizzly bear in the Rocky Mountains, and of the African elephant in Botswana. This intimacy with his subjects has more than once brought him within a whisker of losing his life.

He has done this again and again – tattooing, as it were, on his inner eye every nuance of form and movement giving each subject its uniqueness. Every

one is a beautifully *honest* re-creation of the creature as God made it and meant it to appear to us.

The physical act of transformation by a sculptor of his raw materials to a finished piece requires mental dedication and commitment. But it is much more than this because both David's spirit and the spirit of his subject are connected in many subtle ways. In a way, he is playing God as he builds his raw clay or chisels away at his stone. Visible tangible life is the end result. David's investment in long and intimate pre-study of his subjects gives him the sureness of inner acquaintance and from it a vigour of expression of *life energy*.

In June 1985 the Prince of Wales unveiled the Christ figure for the West Front of Wells Cathedral. Winning and completing this commission so successfully required, as Graham Hughes so aptly said, 'great courage and confidence'. It takes a strong spirit and ego to say to the world 'behold the face of Christ'.

Yes, David Wynne has just the healthy robust ego he ought. At the same time, the moment the chisel or clay is actually in his hand, he loses himself utterly and becomes at one with his subject. He has often said he has loved every subject he has ever created. His oneness with his subject is what gives it the coherent radiation of *love* that speaks silently from his every work.

DONALD M. KENDALL
Former Chairman, PepsiCo Inc.

The massive marble sculpture sits there and looks great. The craftsmanship and artistic vision are breathtaking. You wonder how David could find the time and energy to create the wonderful things he does. Maybe somewhere in his eternal search for the good in life lies an important secret of creativity.

Whenever I think of David Wynne, I think of two things. First is the extraordinary *Grizzly Bear* sculpture on the back lawn of PepsiCo. Each day in the springtime when classes of students visit our grounds, you invariably see them running across the lawn toward the huge piece. What makes that old bear so magnetic? Our place is filled with the greatest sculpture of the Twentieth Century – from Moore and Calder to Rodin. Yet I bet more visitors remember *Grizzly Bear* best and love it most.

The other thing I think about is the dinner party we held celebrating the arrival of the sculpture. My clearest memory is of David dancing on a table drinking champagne out of my wife's shoe. I didn't think people actually did that sort of thing . . . until I met David!

PAMELA TUDOR-CRAIG
Art Historian

We have tramped through this century accompanied by images of tearing pain and dismemberment, destructive excavations of despair. David Wynne has always stood apart from this depressing mirror of our predicament. His bronzes are an exhilaration; they capture the very sap of vitality. He has never been one to trail a torn sleeve of misery through the fashionable art galleries. While others have plucked the nerves of their public with a steel quill, he has disclosed, with a keen eye gentled by kindness, beauty and happiness and reverence for the whole of God's creation.

Then, on 10 November, 1990, his beloved wife Gilli died. She had been the inspiration for his most radiant works. What would happen next?

The alchemy of grief has it in common with the ultimate love and longing, that it may propel the suffering from their individual to a universal condition. Our more profound passions pierce the skin of individuality. Beyond the first storms of bereavement there is a quiet place where wisdom may be discovered, where Dante reached Beatrice after he

had traversed the Inferno and the Purgatorio, where Leontes met again Hermione. David Wynne's *Gilli Walking* is in this mode. She speaks for all lovely women won and lost and found again. He has distilled the tenderness, which is the hallmark of his art, into an elegy for her.

The day after her death he returned to his studio. In order that he might mourn constructively, the sculptor deliberately set himself the most difficult task he could devise. He modelled the figure directly in plaster, because it is the hardest medium to use. He chose the walking pose because it is the most subtle, and one that he had not attempted before. Her arms are open and her hands outstretched. She used to walk like that when she was glad. Her beautiful feet tread without haste and without hesitation. She knows the way.

As always happens when the artist is in touch with his deeper self, the sculpture carries more than a single meaning. David Wynne's bronzes have always been conceived in many dimensions, have told from every angle, and from every deflection of an angle. Here there are the added dimensions of time: of a lifetime and beyond a lifetime. The figure of Gilli walks towards him, as she came to his arms in the days of their courtship. Her back is modelled with an equal delicacy of loving remembrance; she walks away from him like Persephone entering the Underworld. Then, as all who have been bereaved discover, she walks beside him through the days of their separation. And finally there is a hint, and more than a hint, of the Gilli who will return to greet him when his turn comes.

The acid test of the quality of an artist lies in the response to suffering and loss. Does the work continue to develop and to deepen through the cruelties of the years? Think of the fusion of colour in late Titian and Turner; Botticelli's Dante Drawings and Mystic Nativity. Providing you have studied their earlier pieces and followed the geography of their progress, you have the key to the deeper journeys they were to take into the caverns of the human spirit. David Wynne's *Gilli Walking* declares him as one of those for whom sorrow has enlarged perception. It is the measure of his stature that he has dared to be so simple, so unobtrusive, so lyrical. No bravura. No panache. Gillian walks like a Kore stepping into the morning of eternity.

THE VERY REVEREND PATRICK MITCHELL
Dean of Windsor

One of the great privileges of my life was working, whilst Dean of Wells Cathedral, with David Wynne on the great figure of Christ to replace the medieval fragment at the apex of the massive West Front of the Cathedral. This sculpture took about eighteen months to complete. It is now so much a part of its architectural setting that it is hard to think of the West Front without it. Yet the project was a daunting one, involving harmony with nearly three hundred medieval figures of high calibre; and the spiritual challenge was immense.

Several distinguished sculptors were invited to put forward their ideas, with supporting sketches or models, to members of the Cathedral Chapter. David's presentation of his vision was masterly and won the day. He made no claim to deep spirituality, but the commission brought out the latent Christian faith which he had developed from Cambridge days and drove him to deepen his faith. This religious approach came out forcefully in the television film which told the whole story of the making of *Risen Christ* from quarry to the finished masterpiece.

When I mentioned 'working with David Wynne', I must make it clear that I had no part in the carving. A chisel in my hand would have been fatal! I was there as a sounding board for David. We met frequently in Wells, where David was determined to absorb the surroundings and to learn wisdom from craftsmen like Peter Cooley, the Superintendent of Works, and David Rice, the Master Mason.

We also met periodically in David's studio in Wimbledon, where Gilli prepared unforgettable dinners in their former farmhouse overlooking the Common; but before dinner we worked hard (and laughed a lot) in the studio. David perched me on an old stool covered in stone-dust, with a strong whisky in my hand, while taped classical music was played. During my early visits, we contemplated two huge blocks of Clipsham stone specially selected from Rutland (large blocks of high-quality Doulting stone were no longer available from the historic Somerset quarry). Like other great sculptors, David could 'feel' or 'see' the figure which would emerge from the blocks. During my

later visits, I would be looking up to the developing figure in its various stages, because it was hoisted high in the tall studio in order to give the right impression from below, since the figure was to be almost a hundred feet up.

Together we worked out the Theology of the Christ for Wells. David had already undertaken a spiritual pilgrimage to France to look at great sculptures of the Redeemer, such as the one at Vézelay; but the design for Wells could not be a slavish copy or a mere pastiche of medieval types from elsewhere: it had to be a creative work which would fit the context and also be reasonably faithful to the evidence of the medieval fragment.

So the Christ for Wells took shape gradually. It was not to be a conventional *Majestas* with crown and orb. The marks of suffering must be present because the nail-holes in the feet of the surviving fragment dictated them: so the hands too must reveal the print of the nails. The face had to betray the evidence of suffering transformed by the triumph of the Resurrection and Ascension. Is it fanciful to compare it with the face of Christ in the great fresco of the Resurrection by Piero della Francesca at Sansepolcro? I am convinced that the medieval *gravitas* of the thirteenth-century figures has been wonderfully matched by the sculptor.

At Wells, the Lord looks down in compassion on the multitudes of visitors and pilgrims who flock to the Cathedral each year, and equally on the inhabitants of the city who pass the West Front to do their daily shopping. Christ's right hand is raised in the traditional form of blessing; but the left hand reaches down in compassion to the people far below. The thought is that of the Fourth Gospel, in which our Lord Jesus Christ longs to draw all men to Himself and so to His Father.

In February 1973 a fierce controversy had broken out in the national press about the whole idea of replacing or completing any of the figure sculpture at Wells. Therefore the great exercise of conservation over the whole West Front, which spanned the years from 1972 to 1986, concentrated on preserving the marvellous originals; but the Cathedral Chapter insisted that a complete figure of Christ in the central gable was essential to preserve the basic theological concept. The dispute simmered on until 1985, when His Royal Highness The Prince of Wales unveiled the new figure and its two supporting Seraphim. From that moment mercifully all criticism ceased, and today the redeeming and reconciling Christ reigns supreme over the chivalry of heaven at the Mother Church of the Diocese of Bath and Wells.

OTHER SCULPTURES

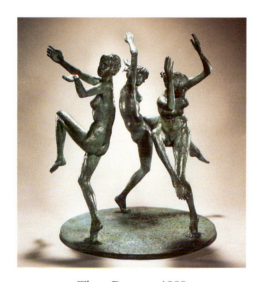

Three Dancers 1989

The following pages show a
selection of other sculptures made
during the eighteen years covered
by this book.

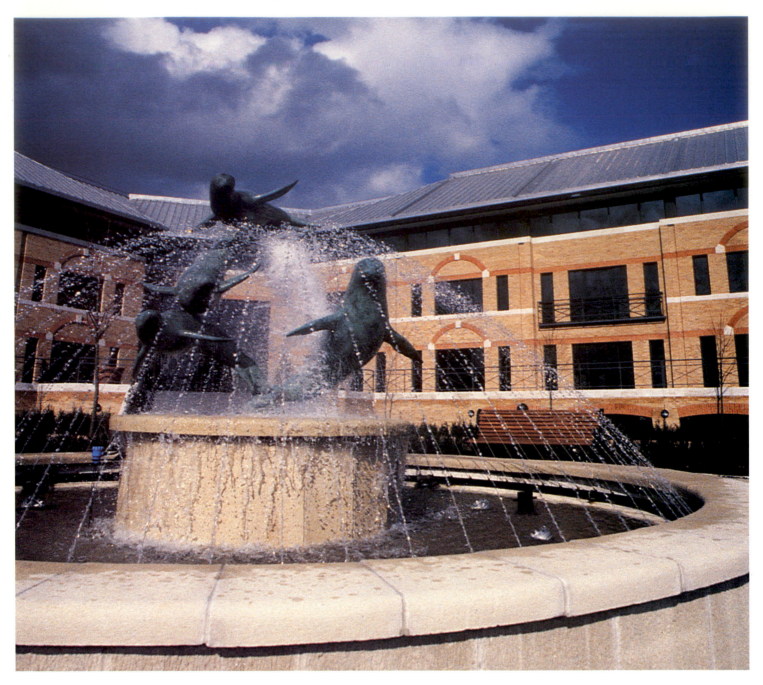

Australian Sealions 1990

Maquette of *Australian Sealions*

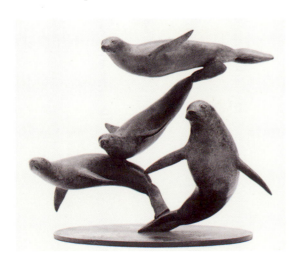

Sealion with Cub 1982

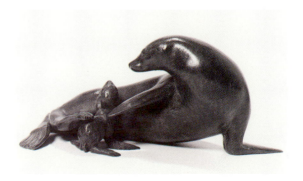

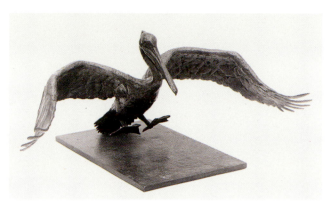

Landing Pelican 1982

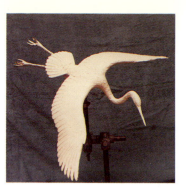

Flying Egret 1985

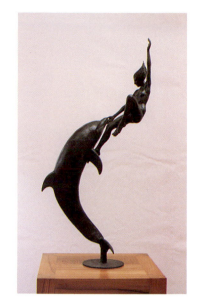

Girl with a Dolphin II 1985

Two Dolphins 1986

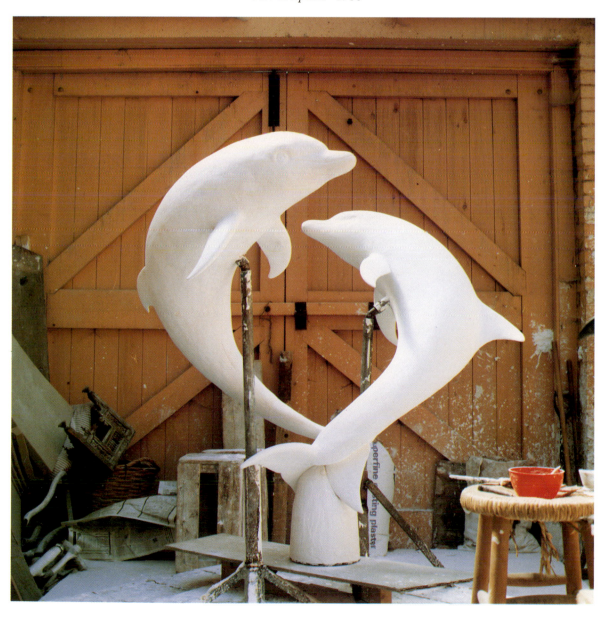

147

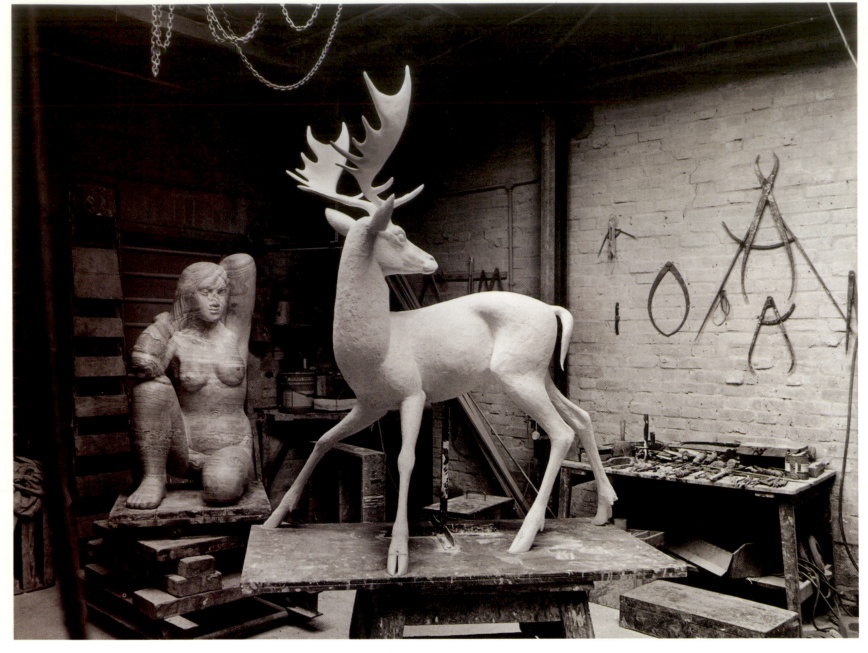

Fallow Buck 1981, with *Gaia* in the background

Grizzly Bear with Cubs 1976

Attacking Grizzly Bear 1976

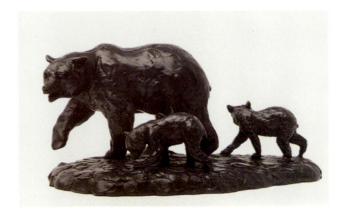

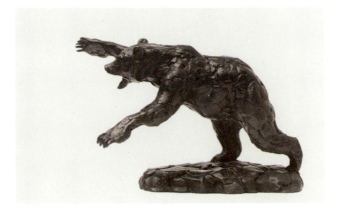

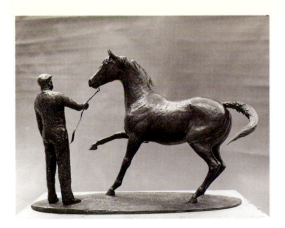

Shareef Dancer 1985

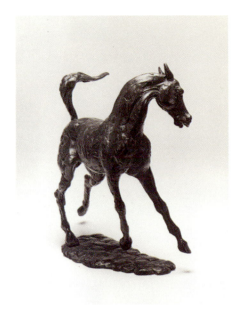

Prancing Stallion 1979

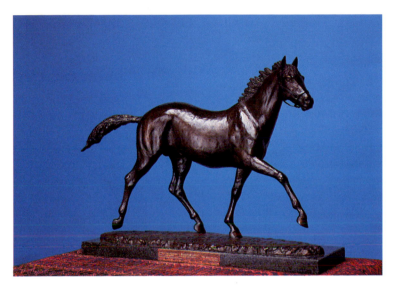

Shahrastani 1988

Shergar 1981

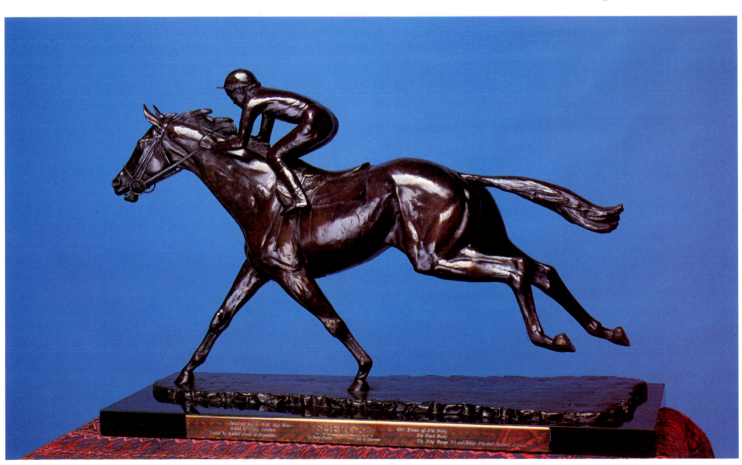

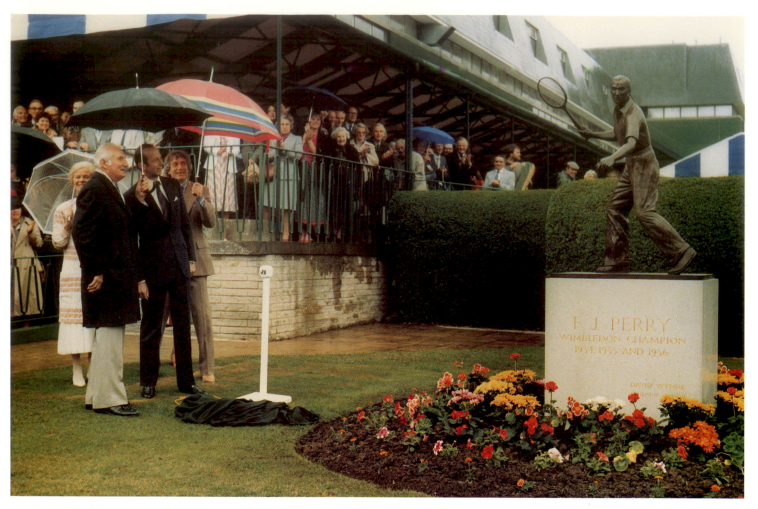

Fred Perry unveiled by His Royal Highness the Duke of Kent outside the Centre Court at Wimbledon 1984

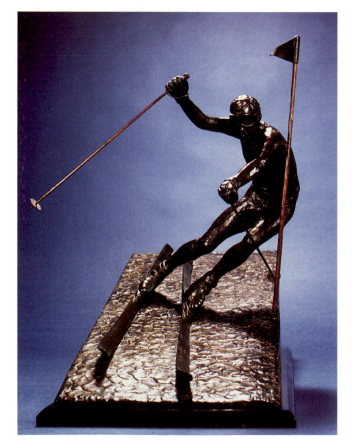

Four champions:
Jean-Claude Killy 1989 (left)

| *Jackie Stewart*
1981 | *Arnold Palmer*
1983 | *Björn Börg*
1984 |

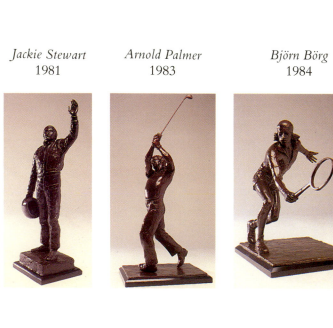

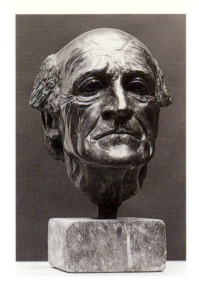

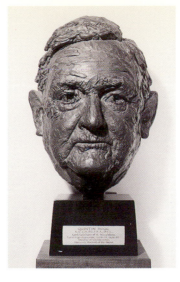

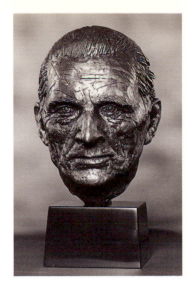

Michael Cardew

Lord Hailsham of St Marylebone

Edward Burn

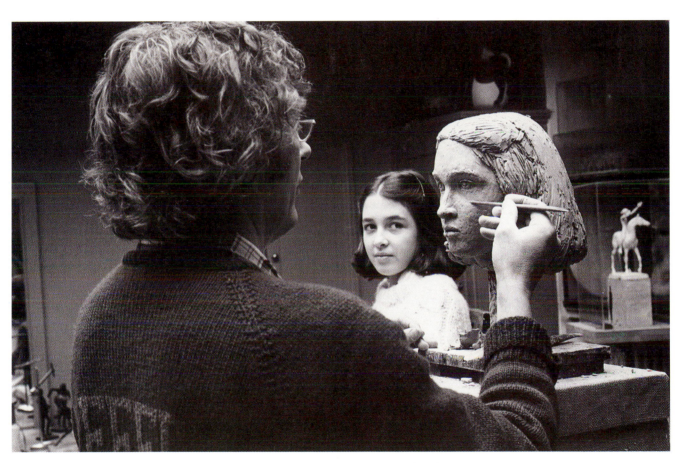

The sculptor at work on *Corisande Albert*

Paul Daniels

Silas Neptune

Grant Simmons

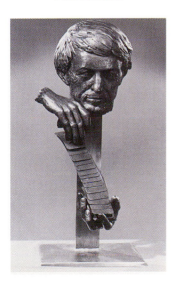

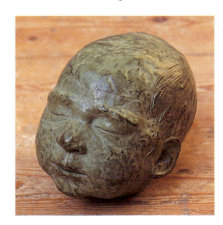

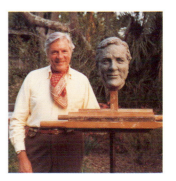

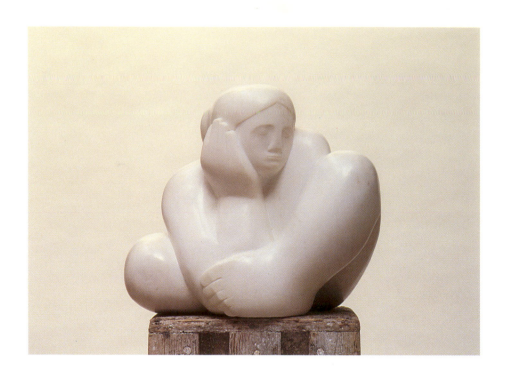

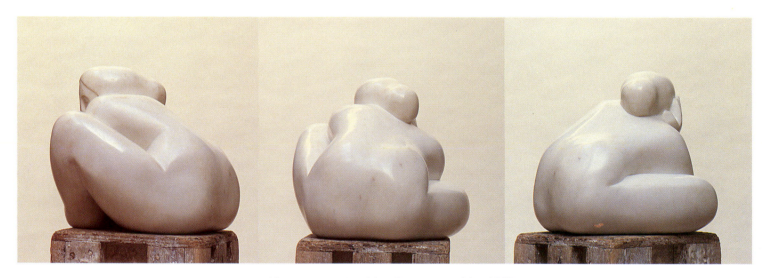

Boulder Carving II, white Carrara marble 1983

Candida 1992

Family Group 1986

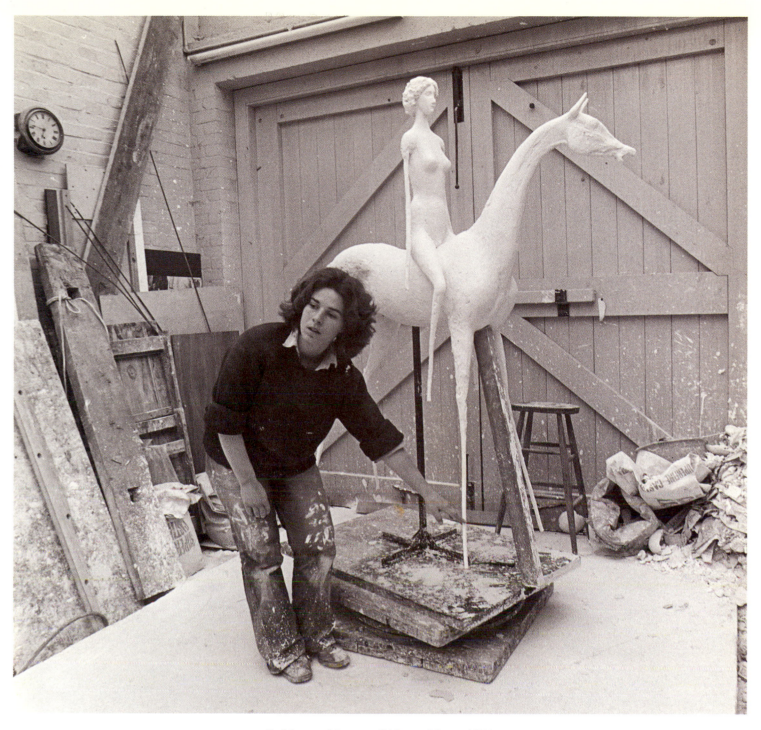

Robin working on *Girl on a Horse* 1976

Mark and Sarah Hue Williams 1991 *Jubilee Medal* *Five Swimmers* maquette 1978

 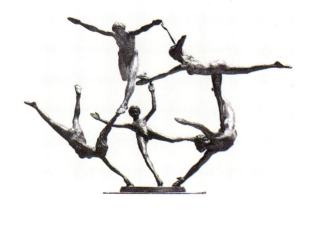

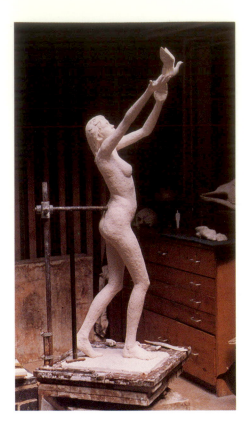

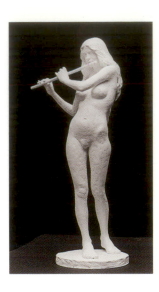

Flute Player 1978

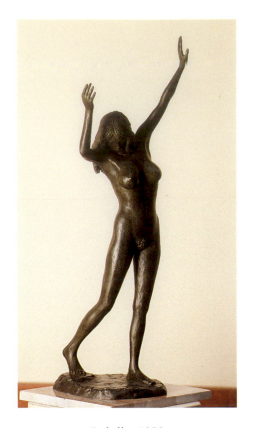

Cath with a Bird 1988

Isabella 1992

Sleeping Girl, Hopton Wood marble 1983

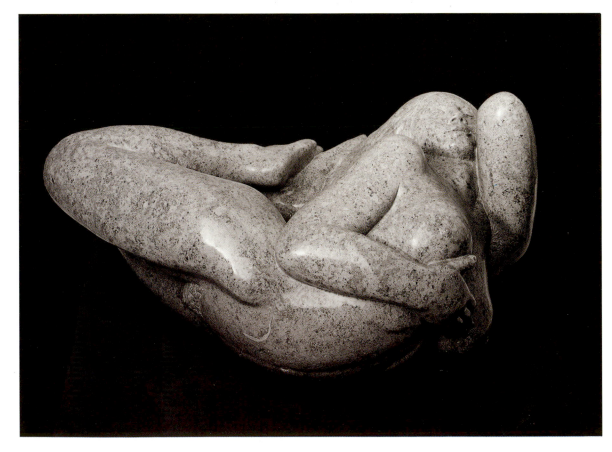

Isabella posing in the Fulham Studio (right)

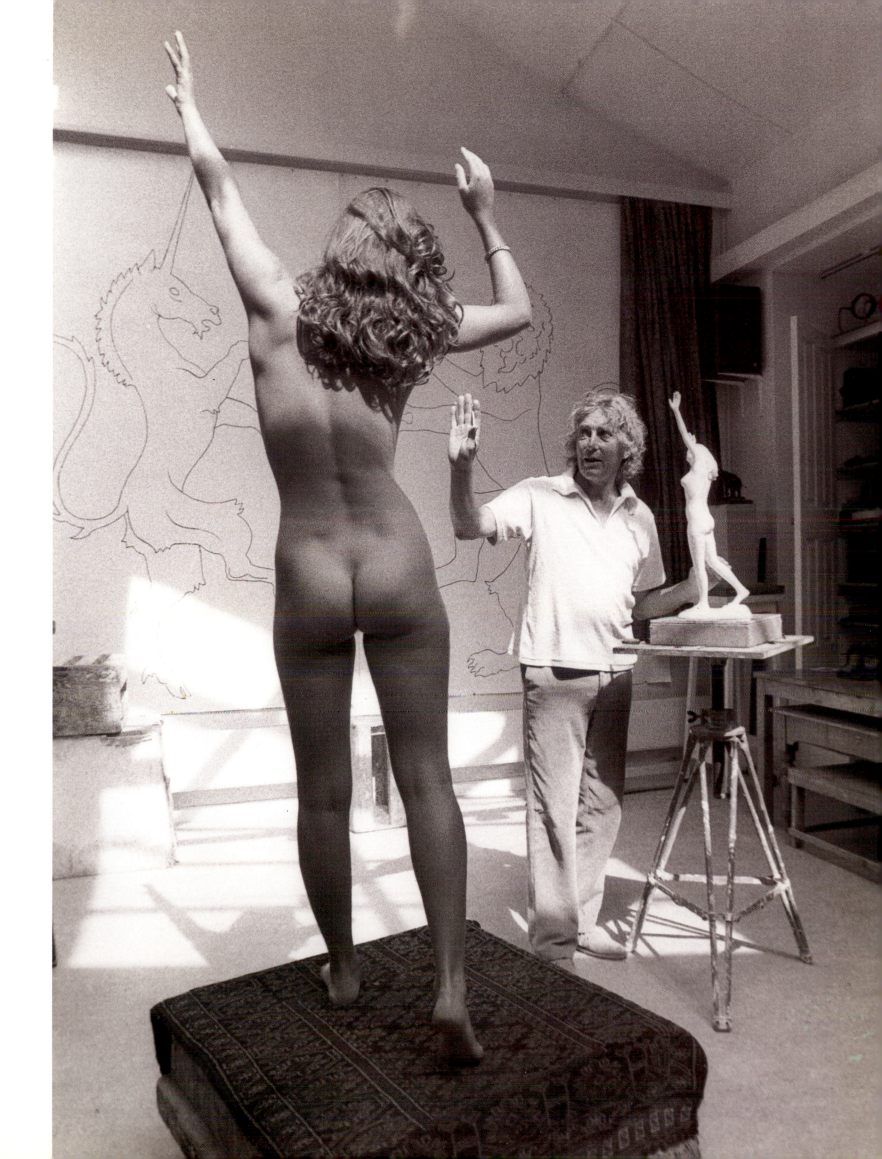

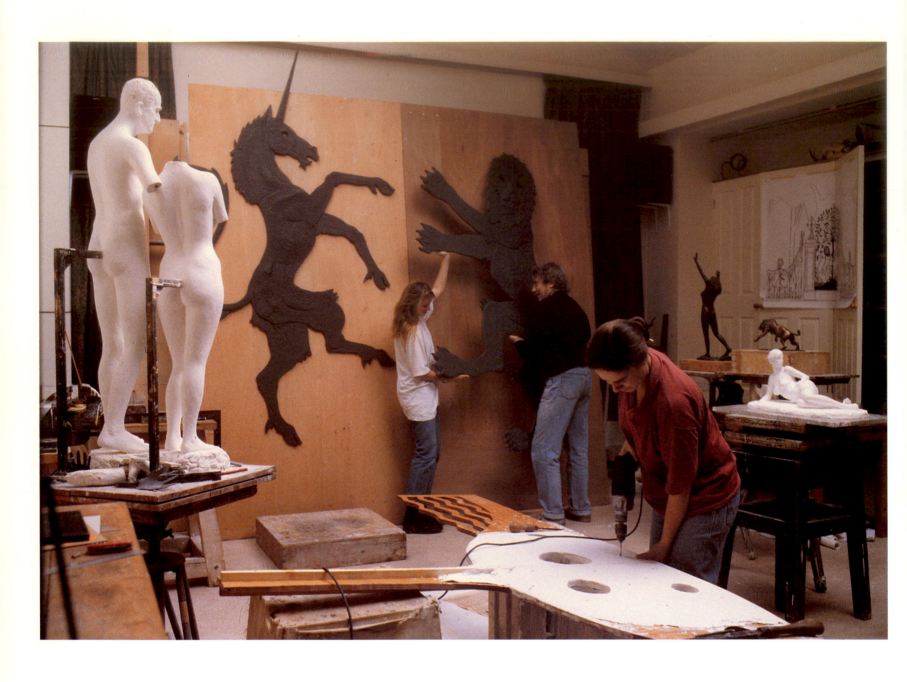

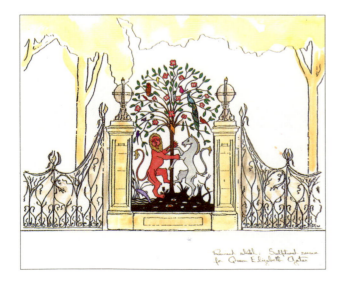

Working on the Queen Elizabeth Gates. Robin works
on the bottom section, as Candida and the sculptor
prepare to offer up the lion. The uncompleted
Bologna Figures are on the far left.

156

CATALOGUE OF WORKS

All sculptures are bronze unless otherwise stated. Sizes refer to the largest
dimension in inches. Bronzes are editions of six casts unless otherwise stated.

1975

Large Bear maquette 24″
Gaia maquette 9¾″
PORTRAIT HEADS:
Edward Wynne
The Begum Aga Khan

1976

Grizzly Bear 168″ (black fossil marble)
Girl on a Horse 64½″ (edition of three)
Bear Lying Down 7¾″
Bear Standing 7¾″
Bear Walking 7″
Bear Attacking 8½″
Bear with Cubs 10¾″
PORTRAIT HEADS:
Graham Hill (posthumous)
Michael Cardew
Pele

1977

Bowood maquette 23½″
Jubilee Medal
William Penn (portrait of a horse) 22″
Kicking Horse 9″
Cantering Horse 10″
PORTRAIT HEADS:
Lord Hailsham
Prince Michael of Kent
Grant Simmons
Peter Rogers

1978

Five Swimmers maquette 31½″
Flute Player 17″
Horse and Rider 144″ (stainless steel, unique)
Countess (portrait of a horse) 12″
PORTRAIT HEADS:
The Aga Khan's Children

1979

Bowood Figure 72″ (Nabrasina marble)
Prancing Stallion 9¾″
Mare and Foal 13½″
Messenger small maquette 11″
Arab Stallion 20¼″ (silver, gilded mane and tail,
 star sapphire eyes, edition of two)
Leaping Salmon maquette 8″ (silver)
PORTRAIT HEADS:
Justin & Corisande Albert

1980

Five Swimmers Fountain 132″ (edition of two)
Messenger maquette 44″
Gaia large maquette 24″
Bull 11¾″ (edition of three)

1981

Leaping Salmon 72″ (stainless steel unique)
Two Swimmers maquette 38½″
Shergar (Derby winner) 33″
Two Swimmers 132″ (unique)
Fallow Buck 72″
Head of Shergar 7″
Jackie Stewart 20″
PORTRAIT HEADS:
The Earl Mountbatten of Burma
Genie McWeeney

1982

The Messenger 132″ (unique)
Leaping Salmon (bronze) 72″ (unique)
Robin Sleeping 13½″
Pelican Landing 18¾″
Pelican Perching 10¾″
Pelican Wings Spread 25¼″
Sealion with Cub 8″
Flying Dove 25¼″ (edition of two)
PORTRAIT HEADS:
Paul Daniels
Jackie Stewart
Sir Nicholas Nuttall, Bart

1983

Gaia 50″ (kudu marble)
Sleeping Girl 44″ (hopton wood marble)
Boulder Carving 16″ (carrara marble)
Sealion Family 21½″
Sleeping Girl maquette 13″
Sleeping Girl maquette 22″
Swimming Seals 9″
Arnold Palmer 26½″
Risen Christ and Seraphim maquette 28″
PORTRAIT HEAD:
Fred Perry

1984

Cresta Rider maquette 14″
Fred Perry maquette 8″
Björn Börg 18″
Fred Perry 60″ (unique)
Fred Perry medal
The Earl Mountbatten of Burma 24″
PORTRAIT HEAD:
George Goulandris (posthumous)

1985

Shareef Dancer (Irish Derby winner) 34″ (edition of four)
Risen Christ and Seraphim 96″ (limestone)
Cresta Rider 72″ (unique)
Five Egrets 72″ (panel, unique)
Lucy Ropner 12″ (unique)
Greyhound 9″
Sophy Knapp 17″
Girl with a Dolphin II 29″
Two Dolphins maquette 17½″
Three Horsemen 26″

1986

Red Hind Licking Foot 44″ (unique)
Two Dolphins 48″
Joseph (baby) 6½″
Joseph (baby) 6″
Family Group 9″

1987

The Awakening Earth maquette 4¼″
Saint Raphael 48″ (unique)
Big Horn Sheep maquette 12″ and 8″
Gerenuk 17½″

Gerenuk Reaching 19¼″
PORTRAIT HEAD:
Charles Cormack

1988

Shahrastani 29″
The Awakening Earth 42″ (turkish green marble)
Cath with a Bird 50″
Kahyasi 32½″
PORTRAIT HEAD:
Lionel Bryer

1989

Big Horn Sheep 51″ (unique)
Jean-Claude Killy 24″
Three Dancers 34″
Eleanor Kaye and Labrador 13″
Tresco Children maquette 23½″
Giraffe 32″
Four Sealions big maquette 14″
PORTRAIT HEAD:
Olivia Brewer (infant)

1990

Australian Sealions 78″ (unique)
Tresco Children 120″ (edition of three)
Two Swimmers with a Dolphin 28″
Goddess of the Woods maquette 20½″
PORTRAIT HEADS:
Edward Burn
Silas Neptune (baby)

1991

Gilli Walking 38″
Mark and Sarah Hue Williams 18¾″ (1/3)
Goddess of the Woods 41½″ (marble)
Elephant Walking 9½″
Elephant Feeding 13″
Elephant Charging 12″

1992

Lion Charging 13″
Isabella 26¼″
Kudu unfinished
The Queen Elizabeth Gates (centre screen) unfinished
Bologna Figures unfinished
Candida unfinished

Any discrepancies in the dating of sculptures can be attributed to the interval between completion of the work in the studio and its installation.

BIOGRAPHICAL OUTLINE

1926 Born on 25th May in Hampshire. Educated at Stowe, then at Trinity College, Cambridge, where he read Zoology. The war interrupted his studies and from 1944 to 1947 he served in the Royal Navy. Returning to Cambridge, made his first efforts at sculpture and unofficially studied history of art under Professor Andrew Gow.

1949 Decided to become a sculptor. Encouraged by Jacob Epstein, and took lessons from George Erhlich, then living in London.

1950 Exhibited at the Leicester Galleries, London, 'Artists of Fame and Promise'.

1951 Worked in Paris for Paul Landowski, and studied with the American architect, Welles Bosworth.
St John the Baptist, bronze, 6ft (Church of St John, Rudmore, Hampshire, now in Portsmouth Cathedral).

1952 Exhibited at the Royal Academy, Summer Exhibition.

1953 Spent the summer in Greece and the Holy Land. Taught art for one day a week at Langford Grove Girls' School for next five years.

1955 First one-man show at the Leicester Galleries.

1957 *Archer Carving*, Portland stone, 17ft (Longbow House, London).

1958 *Teamwork*, granite, 16ft 6in (Taylor Woodrow, London).

1959 Second one-man show at the Leicester Galleries. Married Gillian Bennett (née Grant, daughter of the novelist Joan Grant).

1961 *Guy the Gorilla*, black fossil marble, 4ft 6in (Crystal Palace Park, London, commissioned through the Arts Council for LCC).
Birth of his son Edward.

1962 *Breath of Life* Column, marble, 17ft (British Oxygen Company, London).
Fire Figure, aluminium, 40ft (Hanley, Staffordshire).
Christ and Mary Magdalene, bronze, 6ft (Ely Cathedral).

1964 One-man show at Tooth's, London. One-man show of drawings at the Temple Gallery, London.
Birth of his son Roland.

1966 Second one-man show at Tooth's.

1967 One-man show at Findlay Galleries, New York.
The Pasadena Bird Fountain, bronze, 38ft (Ambassador College, Pasadena, California).
Circling Birds, bronze, 5ft (City of Perth, Western Australia).
Swans Carving, Carrara marble, 4ft (Ambassador College, Hertfordshire, England, now in Pasadena, USA).

1968 *God of the River Tyne*, bronze, 16ft (Civic Centre, Newcastle upon Tyne).
Swans Fountain, bronze, 28ft (Civic Centre, Newcastle upon Tyne).

1969 Second one-man show, Findlay Galleries, New York.
Swans Fountain, bronze, 28ft (Big Sandy, Texas).

1970 One-man show at Covent Garden Gallery, London.
The Lovers, Norwegian rose marble, 6ft (Neison Harris Collection, Chicago, USA).
The Embracing Lovers, Nabrasina marble, 4ft (The Guildhall, London).

1971 Second one-man show at Covent Garden Gallery.
The Girl with the Doves, bronze, 10ft 6in (Cadogan Place, London).
The Dancers, bronze, 10ft (Cadogan Place, London).

1972 Exhibition of Portrait Heads at the Fitzwilliam Museum, Cambridge.

1973 Third one-man show at Findlay Galleries, New York.
50 Pence Coin for the Royal Mint, 'Linked Hands', to commemorate the entry of Great Britain into the Common Market.
Girl with a Dolphin, bronze, 17ft (Tower Bridge).

1974 *Boy with a Dolphin* (Worcester, Mass., USA).
Dancer with a Bird, 8ft (Cadogan Square, London).
Girl with a Dolphin (PepsiCo World Headquarters, Purchase, New York).

1975 Exhibited in a figurative sculpture exhibition in Holland Park, organised by the GLC.
Travelled to the USA to study grizzly bears.

1976 *Grizzly Bear*, Retrospective exhibition of sculpture at PepsiCo World Headquarters, Purchase, New York to celebrate the American bi-centenary and the artist's 50th birthday.
Girl on a Horse.

1977 *Queen's Jubilee Medal*
BBC Television documentary 'One Pair of Hands'.

1978 *Horse and Rider*, Exhibition, Fountain Precinct, Sheffield.
BBC documentary series 'Taking Shape'.
Bowood Figure.

1980 Retrospective exhibition, Cannizaro Park, Wimbledon, London.
The Five Swimmers Fountain.

1981 *Leaping Salmon, The Messenger, Two Swimmers, Fallow Buck*.

1983 Commissioned to carve *Risen Christ and Seraphim* to replace the original figures from the West Front of Wells Cathedral.
Sleeping Girl, Boulder Carving.
Retrospective exhibition at Agnew's Gallery, Bond Street, London.
Sailed up the Nile painting watercolours.

1984 *Fred Perry*.

1985 *Risen Christ and Seraphim, Cresta Rider*.
Channel 4 Television documentary 'The Chivalry of Heaven'.

1986 *Two Dolphins, Saint Raphael*.
Journey to Kenya to make watercolour paintings.
The sculptor was gravely ill in hospital for two months.

1988 *The Awakening Earth*.

1989 *Big Horn Sheep, Three Dancers*.

1990 *Gaia, Australian Sealions, Tresco Children*.
Silas Neptune, the sculptor's grandson, born.
The sculptor's wife Gillian died, 10 November.

1991 *Gilli Walking, Goddess of the Woods*.
Journey to Savuti, Botswana to model elephant sculptures.

1992 Moved from Rushmere, Wimbledon to Burlington Lodge Studios, Fulham.
WORK IN HAND: Central panel for The Queen Elizabeth Gates, Hyde Park Corner, London.
Bologna Figures.

PHOTOGRAPHIC CREDITS